henry moore

henry moore

Elda Fezzi

Hamlyn

London New York Sydney Toronto

twentieth–century masters
General editors: H. L. Jaffé and A. Busignani

© Copyright in the text Sadea/Sansoni, Florence 1971
© Copyright in the illustrations SPADEM, Paris 1971
© Copyright this edition The Hamlyn Publishing Group Limited 1972
London · New York · Sydney · Toronto
Hamlyn House, Feltham, Middlesex, England
ISBN 0 600 35929 8

Filmset in England by Photoprint Plates, Rayleigh, Essex
Colour lithography: Zincotipia Moderna, Florence
Printed in Italy by: Industria Grafica L'Impronta, Scandicci, Florence
Bound in Italy by: Società Editoriale Poligrafici il Resto del Carlino, Bologna

Distributed in the United States by Crown Publishers Inc.

contents

Colour plates

Black-and-white illustrations

Moore and contemporary sculpture

To understand the work of Henry Moore one has to go deeply into the evolution of all modern sculpture which must be seen as the expression in matter and space of a profound penetration of reality and nature. Modern developments in sculpture certainly show signs of an intensely debated, almost laboured, origin. But this characteristic reveals in a compact, final way the difficulties implicit in the contrasting alternatives created by the tensions and experiences of renewal which have marked the last decade of the nineteenth century and the early years of our own. Sculpture took part in this renewal and often acted as interpreter of significant action in the demand for change and replacement in the language, functions and values of the aesthetic world. Indeed it seems to have suffered an even harder conflict in the difficult, crucial debate over object, image and space. The artists who revived these problems, aspects and aims, such as Degas, Matisse, Rodin and Maillol, had emphasised their importance and suggested that their task was to open up and confirm the vast, concrete possibilities of material and form. In reviewing the restless development of sculpture during the first two decades of the twentieth century, we can already discern the many-sided arguments that all successive experiments of the next decades were to take up. Particularly striking is the research into semantics and constructivity, into theories about knowledge and imagination and the complexity of the difficulties and their solutions. Moore's sculpture is a kind of compendium of that tremendous effort to prove that sculpture is a valid language for our time.

Even his earliest work shows the influence of previous and contemporary experiments directed toward renewal. At the same time its enquiry is informed with a technical severity which still aspires, like the sculpture of Rodin, Matisse, Arp and Ernst, Giacometti, Laurens, Archipenko and Boccioni, to imprint upon the work, in both its evolution and significance, the mark of art as a product of choice and qualification. One thing that is particularly connected with Moore, rather than any contemporary, is the progress made by science in the field of organic and inorganic substances. But Moore's vision endows them with mystery and he perceives their changes of form in a kind of alchemical recreation. From this stems his continuous activity in all kinds of material and form: from embryo to man, from rock to shell and bone. Moore's experimentation also clarifies our sense that evolution is neither easy nor painless: it is charged with many shades of feeling. He rejected right from the start the image as a given object, believing that sculpture skirts the edge of the precipice of material chaos and merges indistinguishably once more with rock, earth and mountain. But one is constantly reminded, ethically as well as aesthetically, of the intervention of a workman who leaves his own clear imprint on his

material. In statements made by Moore and in critical commentaries on his work, we often find metaphorical images inspired by his sculpture: the figure as a rock, like the mounds of stony waste which tower beside the mines of Yorkshire where the sculptor was born and spent his youth. But each work by Moore still keeps faith with a *work in progress* compounded of attention to history and to today, participating in and clarifying itself and the world by its action and construction. This concept is present in all the greatest artists of the first half of this century even if directed towards utterly diverse methods and functions. To understand Moore's aesthetic stance, however, it is more relevant to bear in mind the meeting of conscious volition with the reactions of the subconscious. This complex seam was seen by his first interpreter Herbert Read who pointed out what we might call the conservative components that Moorian sculpture shares with that of some contemporaries: 'the same concern with the qualities peculiar to sculpture, namely sensibility to volume and mass, the interplay of void and solid, the mythical articulation of planes and curves, the unity of conception'. These he differentiated from those elements of his vision and craft that took place within a world of magic. These are the two predominant forces in Moore's work, and I would call them the feeling of life and the feeling of myth. From the life source derives all that is represented by Arp's word 'concretion': formal coherence, dynamic rhythm, the perception of an integral mass in real space. His mythical feeling gives mysterious life to his figures and compositions, gives them, in a word, their magic.

Throughout his active life – now more than fifty years – there is woven into his work a sort of grandiose visual and psychological panorama of all the convergences, reactions and responses to external events, of the cultural and experimental questions which the avant-garde were airing in the various critical phases of the first two decades of this century. Moore, who was born in 1898, seems, in his earliest works in the twenties, to echo the discoveries and innovations of Brancusi, Picasso, Archipenko, Laurens, and Lipchitz. But his sculpture already displayed signs of a quite individual origin which can be traced back to the theoretical and plastic experiences that had formed the basis of English art since the nineteenth century.

A long apprenticeship and then teaching delayed Moore's encounter with the principal actors in the English artistic revival. But he seems to have become aware of modern experiments through some of the personalities at his school, such as Michael Sadler, Vice-Chancellor of Leeds University, who had bought works by Cézanne and Gauguin even before 1914, and who had translated Kandinsky. And Sir William Rothenstein who knew of the developments in France and had long admired Degas and Rodin. But it was the essays of Roger Fry that particularly influenced Moore, with their extremely fine Hildebrandian intuitions about sculpture. Read, who qualifies the influence of the 'false aesthetic' of Hildebrand, has nevertheless underlined the positive side of the concept of 'a direct technique of sculpting as distinct from that of modelling' which Fry adopts and which Brancusi also fully recognised.

The fruit of the cultural and artistic experiments which had been undertaken on the continent reached English circles with the Impressionist Exhibition of 1910. This was at once perceptively reviewed by Roger Fry and was echoed in the work of Matthew Smith. Cubism and Futurism arrived in 1914 with the Vorticists. But these movements were all filtered through English culture. This contributed its own particular awareness which had been re-invigorated by the concepts of Ruskin and Morris, by their stimulating concern for a 'vital' art brought back to consciously selected values; and for artistic output to show the influence of psychology and scientific theory as well as ethical and social needs.

But it is difficult to establish whose ideals Moore followed, except for his immediate response to the teachings of Fry and, as a direct result of this, to the great history of primitive art in the British Museum. And in this context we are almost immediately struck, even in Moore's earliest works, by his

concern to rediscover the true reasons for the sculptor's work, reasons which had been examined ten years earlier by the 'new' sculptors.

Moore's work is both like and unlike that of other twentieth-century masters, and like that of so many, does not lend itself to systematisation within the terms of specific programmes or movements even if we are obliged, when reviewing the course of his life, to refer to their occurrence and influence. What becomes particularly clear is how his work is set within the vast framework of current debate and articulates themes borrowed from it, sometimes contrasting ones. But they are always worked out and explored in terms of a strictly visual culture which is connected, however, to wider fields of thought which do not pertain only to sculpture. Although Moore's oeuvre is totally centred upon the role of sculpture (which we can see even in his drawings), of its materials, its true *raison d'être*, its feats and aims, his own intentions and inclinations are so deeply connected with cultural and human interests, with understanding his own times and their crises, that we can hardly consider them the natural result of experience of earlier decades. His development, in other words, precedes and extends exploratory soundings which even today seem richer and more fertile than some later experiments which owe a lot to his prolonged activity as a sculptor. Moore's work has continued from 1922 till the present day in a spirit that speaks with gravity and eloquence, that gives birth in monumental dimensions. But his creative impulses examine so wide a number of propositions and issues that they still appear rich in suggestion and acutely polemical statements. For instance there is the sensation of anti-sculpture that permeates the conception of the complete circle which is contradicted by the perforation of the figurative body; disturbing presentiments are thus born within that appearance of calm, around unknowable forces. The influence of Surrealism brings him to feel the obscure energy, but also the vitality of existence, of doing and being. So that while, in the war drawings, he recalls historical images, he endows them with a sense of participation in everybody's deprivations. The images dilate and re-emerge in unusual archetypes. Indubitably in history such as this the inexhaustible matter of the universe receives its own order. It is as though the task of constructing something unique found the way of elucidation through the operative, creative process itself. Herbert Read saw it and his comments are useful for understanding the origins and motives of this art. An active literary supporter of the avant-garde movements in England, especially those between the twenties and the second World War, he helped interpret continental revolutions within the evolutionary, but not revolutionary, context of his national culture. His thought seems to mirror the work of Moore and Nicholson, Barbara Hepworth, Sutherland, Wadsworth and Nash, Pasmore and Coldstream and other leading figures who met the demands of the artistic revival of the thirties. This was the time of the second wave of propositions, meetings and work schedules – rather than ideologies – after Vorticism.

Read's thought can also help us towards an understanding of Moore's selection by his theory that there was an antithesis noticed early and rapidly evaluated by the English, between two guiding concepts, both at operative and philosophical levels. These led the main interpreters of the modern movement in one of two directions. Read has revised his first studies of Moore's work in the introduction to the fourth edition of his monograph *Henry Moore – Sculpture and Drawings* (1957). In this he has deepened his analysis of the 'organic' principles of sculpture as opposed to the 'constructive' principle. Contrast and debate between these two concepts are present in the works of various modern sculptors who have chosen either the 'organic' or the 'constructive', such as Brancusi, Archipenko, Lipchitz, Laurens, Duchamp-Villon, Giacometti, Arp, Schlemmer, Titlin, Pevsner and Gabo and Barbara Hepworth. 'The history of modern sculpture from Rodin to Moore is the history of the conflict, not wholly illuminated, between these two principals . . .' But Read then goes on to demonstrate a possible common point between these two concepts in his direct comments on the personalities

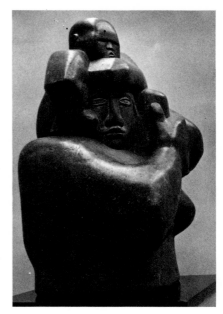

1 *Mother and Child* 1924–25, Hornton stone City Art Gallery, Manchester

and their works, maintaining that 'the organic and the constructive are derivations of the same source; an elaboration of the same reality with different emphases'. Nor can it be denied that in architecture too, where 'the constructive principle generally appears appropriate' the organic principle has also had its periods of prominence as, for example, in the work of Frank Lloyd Wright. Read's argument tends even in organic sculpture – which features with outstanding power in Moore's work – to find the observance and clarifications of 'mathematical laws' just as in the works of a constructive artist. And it is again at the level of the cognitive and aesthetic qualities shared by the strongest personalities among contemporary artists that Read acknowledges that the constructive artist also proceeds by 'intuitive methods rather than by calculation'.

Moore's comprehension of Brancusi stemmed from the conviction, widespread among the English, that he held a special position in this debate, naively one 'of relatively calm detachment' (Read). Just because of this his output assumed key importance, despite its straining towards 'absolute balance and vigorous essence of form, it retained 'a quality of life'. The theoretical argument of the English concept of organism is connected with that of vitality (a concept that Wright introduced into architecture) which in turn goes back, as Argan observed, to 'the theme of typical and vital beauty in Ruskin and Morris'. This is the origin of Read's choice of ideals and his position (or Moore's) in relation to 'organic' and 'constructive'; his tendency to see working out the organic as an ideal and more meaningful expressive purpose. 'The process of constructivism' Argan goes on, 'is an intellectual process, the process of all types of classicism. The process of the organic is inductive, one of participation and *Einfühlung*. This vision becomes 'total act'. Nature is a problem solved, a conceptual representation; reality is an unsolved problem, the crisis of knowledge. Nature is a past which can be known historically (while emotion is a rediscovery and a re-living) and reality the absolute present which is grasped and lives in the act. Sculpture to Moore is the act: the act of taking shape and growing.'

Moore was to move far beyond the direct influence of Brancusi, chiefly because he realised that his was an extreme, closed conceptual position. His work remained susceptible to other influences covering a far wider and more complex range of manifestations of reality. He believed that every living form is 'vital' and that 'a work of art is some kind of concentration of this vital force'.

Together with his sculpture, Moore's 'statements' which were published in journals and reviews from 1930 onwards show how fully he participated in the ancient and modern problems of sculpture and art in general. They reveal a true determination to penetrate the difficult world of matter and form, following an authentic, immediate vision of what he knew. That is why his struggle acquired characteristics and issues of almost titanic quality, getting involved with structures that sometimes attain grandeur, sometimes hollowness in space, so that its amplitude and impenetrability might be made concrete. It even becomes an anti-sculptural process which at times presents primordial norms as mythical apparitions and at others the growing metamorphosis in a figure object almost like science fiction. Sometimes, again, the matter is shapeless, scored like the earth's crust, solemn, defiant and of great age. Certainly Moore has unearthed 'a buried treasure of universal forms of great human significance', and, by delving into primitive experience again, has 'launched the growth of a world interest in sculpture, the alternative of a new creative principle' (Read). Each of Moore's works is born from the quest for a basic, elementary order in forms. Even in instances when the organism of matter as form seems to grow like a kind of fatal implosion, through layers of impulses and the inner thrusts of some obscure body, there is always the sign of his desire to elucidate, which works with and ultimately dominates the development of the object that is being born from the wood, stone or clay as if from unknown forces. The world of the subconscious is probably one of the sources from which the freest and most

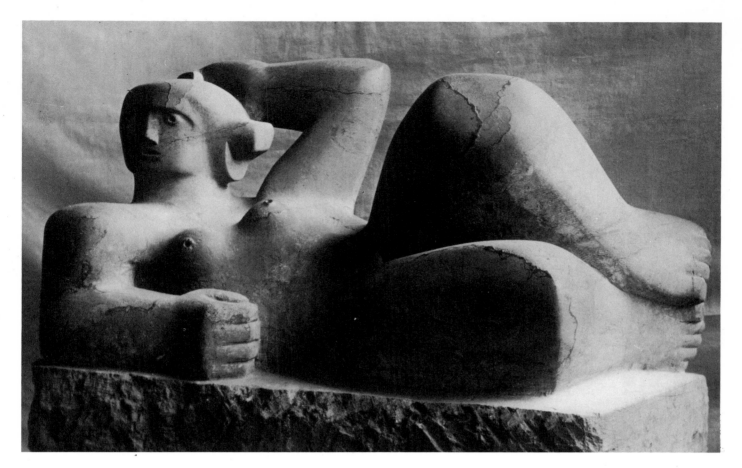

2 *Reclining Figure*
1929, Hornton stone
City Art Gallery,
Leeds

powerful of Moore's ideas spring. Yet he uses that source with a coherent awareness of the instruments made available by current sculptural experience, which becomes the heritage to which the sculptor responds. The primitive and its manifestations reappeared in painting and sculpture via the works of the Post-Impressionists and Cubists, and these abounded in highly skilful attempts to explore and express a new reality. In the realm of sculpture these developments were shown keen attention by two important artists working in England: Jacob Epstein and Henri Gaudier-Brzeska. Moore's return to the 'womb of prehistory' (Piper), via the cultural preoccupations of human science and artistic discovery, can be seen as a move of the greatest value since it provided a source of knowledge and a whole range of hitherto unspoken visions. His contact with the reality of the world, as well as with that revealed by science, was enriched with a profound understanding of the truths manifested in ancient art understood as being part of existence. That is why what he learnt from Sumerian, Negro, Cycladic, pre-Columbian, Roman, Polynesian and contemporary art was not merely iconographic notions. Owing to his impulse to relive them in actuality and in the reality of his own being, all Moore's sculpture also evinces the perennial conflict (that 'hidden struggle' whose presence he noted in all the best sculpture of past and present) to recreate a vital formal process, born in the very act of sculpting. Moore's conflict becomes even more tense as he extends his knowledge of the parallels and oppositions to his own work, the experiences of Abstraction-Creation, Constructivism, rationalism and even Surrealism. But the state of conflict is productive because it establishes a positive area of debate about productive artists' work, relating it to the time and condition of society in which it is born. 'Everything that breaks out with energy is disturbing, not perfect. It is the quality of life – it is the same disturbing quality that makes us distrust things too easily obtained. I have always distrusted what comes easily to me.'

His first point of conflict was encountered at Leeds Art School and was to continue at the Royal College of Art. The ideas imparted by academics contrasted with what the student had learnt from other sources (Sadler,

**The life
of matter
and form**

Rothenstein, Fry). But he had to continue his attendance for several years in order to obtain the teachers diploma. He practised with the pieces of sculpture suggested as models, plasters retouched from year to year, whose form was no longer perceptible since it had originally been no more than a poor copy. Drawing from life seemed a much more valid exercise, permitting not merely the expression of a sterile, synthetic imitation of a model, but the perception of form in an image which was an expressive entity in itself. His chance encounter with Fry's book *Vision and Design* published in 1920 was absolutely decisive. Everything is there, according to Moore, and the essays really opened the way to other reading, and above all stimulated him to visit the British Museum. Fry advocated re-interpreting both ancient and modern works of art and helped Moore to rediscover the fundamental principles of archaic sculpture. This gave him a new vision, beyond his academic training; he was on the point of leaving the school. Studying in the rooms of the British Museum, whose chaotic but imposing collection of primitive art he was to recall years later, made up for copying the lifeless classical plasters which he was compelled to do at the Royal College. The 'drawings from life' which he made in the summer of 1922 tend to perceive volume as continuity and genesis of mass; drawing as a 'single entity' which tends to be something more than merely the sum of its varbous parts (Fry).

The first attempts at sculpture which Moore achieved that summer, freed at last from obligatory scholastic copying, take a decisive stand upon 'the positive representation of relief' which Fry emphasised as a characteristic of ancient Mesopotamian art, Sumerian, pre-Columbian, Negro and Cycladic art presented him with a common quality, a technique of immediacy and unity, corresponding to human necessities and realities. Moore already seems to have some awareness of that 'massive splendour' which invests ancient sculpture. He acquired it himself by summary work at carving, which assumes asymmetrical and rough shapes in the stone. The forms tend to correspond to nature, not reminding us of figures at all. They are already, in fact, the archetypes in his search for a unitary fulcrum which nevertheless contains a lively human presence. He seems to hear the echo of that intransigence and imagination which were salient items in the visions of Blake, where he revealed his 'perception of the elementary forms that govern a spirit with hopes and infinite terrors'. Fry's intuition is equally interesting over the meaning of the emblematic forms in Blake which he saw as an exultant transfixion of nature, 'rich with imaginative, anti-Hellenic excitement'. This transfixion was expressed in forms as 'a visual copy of words such as "ocean", "great waters", "firmament", "the depths of the earth"'.

From the moderns to the ancients the art of history traced by Fry always led back to seeing art as an aesthetic experience free from the imitations of naturalistic forms and unnecessary superstructures. It also led to sorting out the concreteness of its forms as signs and messages. Even the concept 'plastic' took on an original accent in *Vision and Design*. It was connected with 'the most obscure inclinations of the personality that form the individual *Weltanschauung*'. His perception of 'constructive design' enabled him to observe the progression towards 'simple and inevitable form'.

Some of the basic tenets of Fry's literary and aesthetic criticism were in profound agreement with the thoughts and projects of Ezra Pound and the Vorticists in *Beast* and elsewhere (the contemporaneity for instance of primitive language, which was widely used in the Vorticist manifesto inspired by Pound in 1914). In Fry, the idea of 'constructive design' was correlated with that of 'three-dimensionalism' and 'vitality' as typical elements, basic values (including tactile values) in direct relation to the human reality present in the art of primitive epochs and re-expressed by some modern artists. In fact, in the earliest of Moore's works, we are reminded not so much of recourse to this or that archaic work as of an exploration of the active tensions in each work. His basic interest is iconological and only rarely iconographic, stimulated by his need to rediscover authenticity in the act of sculpting through recognition of himself and of contemporary

reality, both in the world and among mankind who had created and lived through primitive imagery. 'Existing monuments form an ideal order among themselves', Pound preached. If single works by Moore reveal an occasional preference for Sumerian, Negro, Cycladic or prehistoric art, his work as a whole constantly displays a desire to perceive the original processes of sculpture. To rediscover its 'vitality' meant to eliminate conceptual formulae which, through the centuries, had smothered the earliest, most authentic structures, the values and functions of acts intrinsic to the reality of the work. The 'finished achievements' of primitive art are so because of the integral force which brought them into being. Moore understood their 'frankness, their primary interest in the basic, and their simplicity'. The masks and completely rounded sculptures of the years 1923–30 revive a timeless archaism with great freedom. Synthesis is achieved by variation in carving, and keeps the asymmetrical impulses of the form in constant tension, the form being seen as material that emerges and dilates in space. As Fry pointed out, in Negro sculpture the mask 'is conceived as a concave surface hollowed out in this completely homogeneous mass'. Negro sculpture revealed an 'utter freedom' by taking no account of Greek or Roman art which understood sculpture as a 'combination of bas-reliefs in front, at the sides and behind'.

Moore's sculpture poses no contention between matter and form, but tends, right from the start, to be a perception of developments in the life of matter and form without considering incidental 'historical' notions of the object. Moore's efforts were always directed to abolishing the limits of the immobile sculptural space of the classical tradition. Fry maintained that space had been defined in the 'conceptual vision' of art at the moment when man 'revealed his desire to classify phenomena'.

Moore's 'regressive archaism' manifested a perceptible tension in connection with these instances, even to the total absorption of the figure into the womb of universal matter. Then the huge figures that followed seem to be samples of biological and geological life. They contain great freedom of emotion. This emotion is implied in the growth that accompanied his effort to regenerate form. Moore's whole output, apart from his theoretical pronouncements, was to lay its emphasis precisely here. Here, too, is concentrated all the social and doctrinal intent that is observable in the sculptor's work. Only in this sense does he accept the utilitarian and experimental functions of art; and herein lies his profound resistance to constructivist and abstractionist programmes. The ideas of the Imagists also had some influence over the English artists active between 1920 and 1930. Between 1910 and 1920 these had concentrated upon the interests of writers, poets and artists. Read has also pointed out the importance of the poet T. E. Hulme, the writer of *Speculations*, who had contested the utilitarianism of John Stuart Mill. A friend of Conrad and Hardy, he had great influence over the generation of Pound and Eliot. In 1924 Hulme had compiled a commentary on *Abstraktion und Einfühlung* by Worringer, in which he emphasised that the vital principle of art was not expressed in geometric art. The restless spatiality of Worringer, says Read, thus came to correspond to the *Angst* of Heidegger. Like Worringer, Hulme recognised in the art of the past the significant coexistance that English theory and the art of the English groups of innovators seems to dwell, especially when the influence of the pioneers of the continental avant-garde first made its presence felt amongst them in the 1930s.

Moore's opposition to formulae could not but refer to the rigours of geometrism and neoplasticism. The feeling of vitality which springs from the immediacy of archaic sculpture was also a direct manifestation of the 'profound beliefs, hopes and fears' of primitive man. In his early works Moore avoided geometrical hatching and careful grading. Synthesis was achieved in each sculpture by the free connection of masses. What mattered was the delivery of the image understood as an 'intellectual and emotive complex at one instant of time', a complex which, according to the tech-

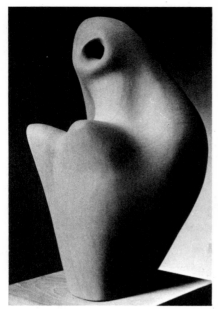

3 *Figure*
1933–34, Corsehill stone
Loren-Ponti collection

nical terminology of modern psychology, 'gives the sensation of sudden liberation; that sensation of freedom from the restrictions of time and space; that sense of sudden growth that we feel in front of all the greatest works of art. Far better to present one single image in a lifetime than to produce voluminous works' (Ezra Pound). Moore's researches seem to refer back to these declarations in their concern with the birth and growth of the figure or rather archetype; that is, the figure of the form that he is unearthing.

New images

Ever since 1922–23 Moore's work had been carried out in roughly finished stone and wood. The form appears in unfinished 'figures' which seem on the point of coming alive. The archetypes of a lay, human mythology are already to be seen; *Mother and Child*, 1922; *Standing Woman*, 1923; *Caryatid*, 1924; *Snake, Seated Figure*, 1924; all in stone or marble. There is an immediate internal urge towards asymmetry which is only just contained in the angularities, retentions and expansions of space. There is a certain emphasis too on the rediscovery of the archaic, but this is introduced through a free invention of new rhythms, and in the contrasts between swellings and contractions. Narrative intuitions lend an expansive character to the austerity of the 'figures'.

His impulse towards the elementary forms that lie below the apparent surface of things is already discernible as heavy masses scratched with areas of primitive carving gradually predominate. These have double features growing from a single lump of stone, flowing egg-shaped masses, and the softness of living shells. The signs of Surrealism that Read notes in Moore's early works (as in those of Paul Nash) can already be seen in some of these early stone pieces, in their affinity with Gaudier-Brzeska and his desire for a universal rather than spiritual or animistic, organic energy.

This course was also the spiral by which Moore was able to abandon the more literary and archaeological forms of primitivism. One might already aver that if Surrealism is apparent in the later sculptures too, it has a strange but lucid physiology which shows no close connection with other more stringent observances of the tenets of continental Surrealism. This is because that element of life and the subconscious, which informs the deliberate openings in the early figures, is a component that aspires to an ethical, spiritual and productive relationship with the world. Even Brancusi's careful refined markings found and continued to do so in Moore, an interpreter already predisposed by his desire for a full, wide view of the world and the artist's job. He almost animates the stone, feels its essential quality and thus its fresh potential as life and image. The variety in his first products reveals close proximity with the diverse interests of Archipenko who was in Paris and had been studying primitive art in the Louvre since 1908. But a little later Archipenko was to find the structure of a scenic space more irresistible, a space articulated by the syncopated effect of silhouettes twisted into concave and convex relationships, achieving a more intellectualised 'modelling of space'. Moore does not have Archipenko's unqualified urge for synthesis and is still less interested in careful refinements of articulation to the point where material becomes misleading.

A psychological interpretation of the matter-form relationship, and its growth in the works of Moore, may clarify his position. Moore himself has stated that the ideas of the reclining figure and of Mother and Son were one of his deepest obsessions. Considering these motifs as 'ideas' and as 'obsessions' we would be wrong, says Newmann, to infer that some visionary's hand has wrought an archetypal, internal image in the manner, for example, of the Surrealists. Moore is indeed the visionary of an internal, archetypal figure that we may call, simply, 'the great mother'. But it is quite clear that in his work as possibly never before in the history of art, an archetypal image, what he calls an 'idea', has its seat in a world that transcends all conceptions of 'internal and external'. This distinction is subtle and pinpoints that basic coherence which causes Moore's sculpture to be the self-revelation not only of the archetype within him, but also the growth of

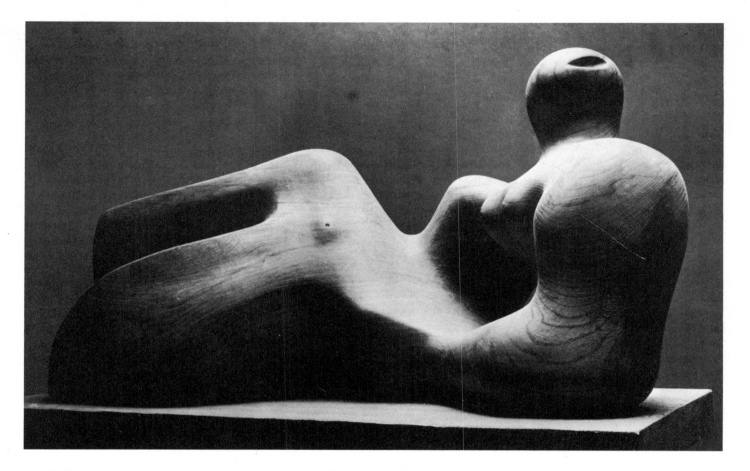

symbolic equations realised in the material which becomes a figure of reality. Undoubtedly, just as the psychologist is not far from the truth when he records profoundly symbolic connections between Moore's archetypes, so Moore himself never gets far from the reality of his own work and personality when, in his theoretical expositions, he chooses to postulate thoughts and suggestions of formal methods and give them a certain prominence.

Truly, if Moore's work is considered as an examination of the 'feminine', we must view this relationship against a very wide psychic, formal background. It is always a question of his relation with life felt in the events and formations of organic development in the entire universe. Hence his concentration on being, at the different moments in his work, the sculptor who perceives and gives life to other forms, to all forms, to rock embryo, and man. Not any one thing, but all things, have fascinated him – above all, 'truth to material', the materials of stone and wood. Early on he preferred stone, took hold of it and sculptured it with no harsh carving. Moore feels stone as part of the earth, the earth which brings forth the forms that are concealed in matter.

But even this element of truth to material, which had assumed more grandiose, almost mystical claims with Brancusi, even this did not become a rigorous principle in Moore's sculpture, which always expresses an ancestral love for life on earth and a wider enjoyment of the various forms of nature. Moore has dwelt long on the forms revealed by rocks, by the heaps of waste he saw as a boy near the Yorkshire mines. And in that stone, which according to alchemical tradition has embodied since antiquity the 'symbol of the difficulty of work' and contains 'a hint of the mythical', he has worked as a discoverer, waiting upon and taking part in the birth and growth of material as form. Stone is respected for its three-dimensionality, but it is also induced to allow form to emerge by itself, with the same conviction that characterises the work of miners and metal workers, that 'they are influencing the growth of subterranean embryology: they are accelerating the rhythm of growth in the minerals and are thus collaborating with nature in her work . . .' (Eliade).

4 *Reclining Figure*
1935–36, wood
Albright Knox Art Gallery,
Buffalo

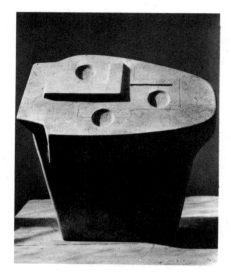

5 *Carving*
1936, travertine
Mrs Irina Moore collection,
Much Hadham

6 *Mother and Child*
1936, green Horton stone,
Sir Roland Penrose collection,
London

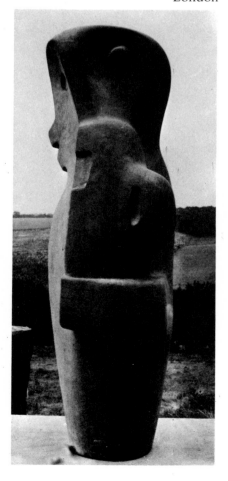

In Moore's earliest works we can see how exactly he recognised the unity of matter. His masses are reduced to their generating principle. Material is internal energy that develops until it becomes animate as form. In the first Reclining Figures of 1926, of which one bronze still remains, a naturalistic body is executed with the generosity of a Maillol. A kind of expansiveness is evident like a slow, Romanesque awakening. Moore's interest in archaic-primitive sculpture also included ancient Norman art, in which he saw the vitality of the ancients still persisting. He thus retained a wide range of historical verifications of the formative and creative necessities of sculpture over and beyond the strict canons drawn up in the process of technical development.

'Every art has its root in the primitive, or it becomes decadent, which explains why the great epochs, of Periclean Greece and the Renaissance for example, flourished and immediately followed primitive periods and then gradually died out.' In 1926, on his return from Italy, he embarked on another period of bitter, 'violent conflict'. The great sculpture of Pisano and Michelangelo, the painting of Giotto and Masaccio, which he loved deeply, were supreme examples of what he considered the 'enemy' of his view of sculpture at that time. In 1927–28 strange shapes emerge which reveal a new organisation of masses. Little scratchings appear on the surfaces and on the heads which stick out from sluggish convexities. He begins to use precious and rare materials, as in the *Head and Shoulders* of 1927. The huge shoulder plays a role of utter anamorphism like the heaving of concealed folds in the ground. A kind of transformed, exuberant naturalism bursts out of these fragmented figures, these lengthened and enlarged busts which stick out from the whole almost as if to assert their profound distortion more loudly. The marble gives them subtle, variegated markings.

In 1929 he produced the exceptional serpentine *Reclining Figure* hewn out of brown Hornton stone, now in the Leeds City Gallery. One subject, a figure lying down, had a long history. It had been, from early Greek to Renaissance times and in classical revivals in every region, a feature of famous architectural and sculptural complexes. But the strongest stimulus to this new approach had been given to Moore not by Classical examples, but by an idol of ancient Mexican art, the Chacmoll. This was a Toltec-Maya sculpture representing the God of Rain which had been found at Chichén Itzá, and Moore had seen a photograph of it in a German magazine. By comparison with the schematic primitive sculpture, Moore's figure is not only concentrated in equally primeval gravity, but the foreshortening of full masses unleashes the compact body of a something between matter and anthropomorphic being. The immovable quality of stone and its roundness are concentrated in calculating the new being's morphological energy. Moore has often talked of stone's mysterious resistance and the way in which it emerges as global, like the earth itself. Stone can be carved directly. Thus one again sees the intrinsic emotional significance of forms and not so much their representational value. This recalls Brancusi's conviction that the meaning and end of sculpture was all in carving and thus in penetrating directly into the material to animate it. This was quite apparent in the works of Rumanian peasants and primitive Africans who had not yet learnt to produce tourist art. The *Reclining Figure* of 1929 clarified Moore's wish to express the three-dimensionalism of stone with all the urgency and extension possible. Thus the whole body of the stone is exposed to the contact of the artist's hand and mind, and he does not waste the real power of his material in ornament and decoration.

'A stone sculpture', says Moore, 'should honestly look like a piece of stone since making it look like flesh, hair, or wrinkles is descending to the level of a conjurer in a theatre.' And early in 1930 Moore took complete hold of this conception of autonomous material as form, bursting into space, pulsating with life and its own identity.

He was reluctant to accept the commission for a bas-relief in the Underground station at St James's, London. The *North Wind,* which he carried

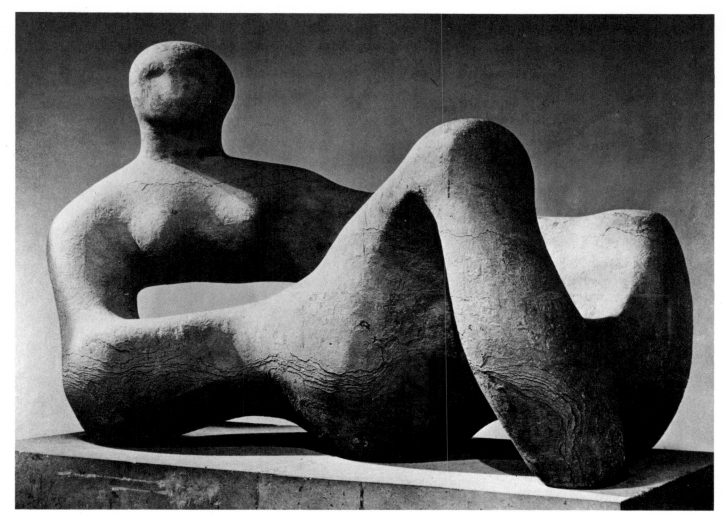

7 *Recumbent Figure*
1938, green Hornton stone
Tate Gallery,
London

out in 1928–29 in Portland stone, goes beyond the limits of bas-relief in its plastic expansion. There were actually several bas-reliefs by Jacob Epstein going up on London monuments at this time. *Day* and *Night*, for example, were sculptured in 1929 and 1930 for the very same underground station, but although Moore much admired them, they no longer satisfied him. Epstein's sculpture with its scholastic resonances and its dense, Egyptian-Cubist modelling could still derive from enclosed space. But Moore's convictions were so strong at the time that he brooked no compromise that might interfere with the most coherent results of his preoccupation with unlimited space.

Thus the *North Wind* became an exemplar for the theories that it bore witness to, of the fundamental principles that were guiding the sculptor. It is an extended figure floating across a wall. It seems to be uprooted from the objective space which, in fact, seems to be restricted. The wall itself limited the full elaboration of the material-formal theory that Moore was gradually working out.

Sculpture is full spatial richness, and what Moore had learned from primitive sculpture was its complete, cylindrical realisation, the sign of concise creative workmanship. The effort to separate the mass of the figure and render it fully is visible even in the horizontal extension of its limbs. Thus the mass appears to float, undulating over the projections of the wall. Moore's theory has been carried out to the full in the carving, in his awareness of the union between form and matter; and he achieves a moment of new, contemporary, Romanesque art. The work recalls the aims of Arturo Martini in his vigorous fragments of 1941: *Girl Swimming, Man's Torso* and *The Bull*. But Moore's premises were to carry him a long way, also, from obedience to monumental canons. He meant to avoid 'the humiliating subservience to the architect'. He was for self-sufficient sculpture (refusing in fact to do reliefs for the London University Senate House in Malet Street)

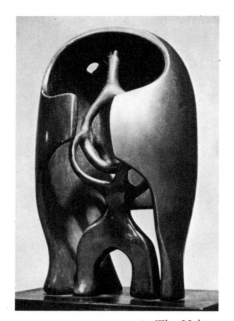

8 *The Helmet*
1939–40, bronze
Mrs Irina Moore collection,
Much Hadham

and was sure that sculpture was capable of occupying a place, shape and space validly by itself. 'The sculpture which moves me most is full of energy and sustains itself, entirely spherical; that is, its compositional forms are fully realised and act as masses in opposition, not being merely indicated by surfaces carved in relief.'

As far as the relation between architecture and sculpture is concerned, Moore's attitude has always been clear. His work aims to be self-sufficient, a presence that grows and develops its own mass through the fullness of its organic life. It is another characteristic that he has in common with Frank Lloyd Wright. They both carry through their vision with great energy in an almost mythical freedom which leaves their own personal imprint on space. If functional architecture, which considered only the essential and was therefore strictly controlled by rationalism, required no sculpture, Moore approved of it. He was not interested in sculpture that served decorative functions. Sculpture that represented an intermediary between a building and a space he often found dispensable. The same view was also held by Antoine Pevsner who foresaw sculpture and architecture functioning independently of each other. The only possibilities that sculpture has in this connection is 'the task of acting as intermediary between architectural space and infinite space'. Moore's relation with architects and architecture was to become easier in later years and with highly original results, as when he treated the entire surface of a façade as if it were a stone to be worked in a sculptural continuum. In the Bouwcentrum building in Rotterdam, the architect was to provide the sculptors space and to hand over the whole organism of the wall to the sculptor.

Perennial human symbolism

In the *Reclining Woman* of 1930, in green Horton stone, now in the National Gallery of Ottawa, there is an even more striking dislocation; a plastic scheme that intercalates successive portions of space. The influence of archaic styles is further shaken by emphatic tensions between smoothness and extreme unevenness of the planes. Considered as a new conjunction of styles it would show those of Laurens, Lipchitz and Arp. There is an extraordinary core of asymmetry here that becomes energetically narrative. His care for the surfaces and their variation follows the course of the material's sudden rises and falls. Every pleasing quality that may be still discerned in the modulation of concave and convex curves is swallowed up in the protuberances, flexions and movements created in the 'figure', a figure that may well make the spectator think of sphinxes and idols, but which suggests even more a piece of earth. The sculptural 'body' is a vast field of hypotheses which can be seen and touched. Sculptures are 'not so much compositions as primitive forms such as nature creates which appear to the sculptor in a way comparable with the creative mobility of nature' (Grohmann). The Reclining Figures of 1930 thus present an extreme exertion of formal imagination. The figures extend all round, in diverse and chance angularities like huge compounds of human larvae. It was in the early thirties, too, that Moore acquired a finer mastery of carving and intaglio, and made use of the evidence of rare ligneous barks, the exquisitely ambiguous malleability of alabaster, and even the tensions of flint to acquire a more intense sensibility to the marking of surfaces. The Reclining Figures are twisted in solemn, shadowy distortions; they stand up like impervious hills. In the *Mother and Son* of 1929 and 1930 (examples now in London), in green Prato stone and Ancaster stone, there is a sequence of swelling torsos, of great arms spread out in vast, jutting curves where the baby is wedged as if in a valley, in the eternal womb of the mother's lap, the bosom of the great Earth Mother. Echoes of primitive Sumerian, pre-Columbian and Romanesque sculpture, in the rooms of the British Museum which Moore never tired of visiting are no longer enough to explain the amplitude of this expression of perennial but uncontrolled human symbolism. There is already a quite decided knowledge of 'the secret rhythm of the aggregation of matter and its formation', which is also 'the rhythm of its growth and

expansion, its occupation of space, and its progressive integration of facts and aspects that are already part of reality, or that belong to that external world in which it unfolds like a living being'.

In these examples, which seem to have been visualised and sculptured on a huge scale even when they measure only a few inches, we see the reflection of a period of an urgent will to explore, illuminated by logic and imaginative passion; and this is always perceptible, however formlessly diffused the mass. Moore is trying to grasp some new sign of vitality. Again, in 1930, he says that he feels sculpture is not symmetrical, but strong and vital, giving off something of the power of great mountains.

The *Mother and Child* of this period is also connected with the half figures which unwind in exuberant extensions of mass. On these there are elementary graffiti, markings and figures that are meant to indicate organic growths and are signs of calls to space from inside. The veining of alabaster is especially striking in the way it emphasises protrusions and hollows, the flexible undulations of the waves of existence. Figures waste away through erosion, as if some crepitation within the matter were causing minerals to fester on its smooth surfaces.

Relationship with continental experiments

In the early thirties Moore's sculpture shows the influence of continental experiments which he learned about through frequent meetings with passing artists and writers. English artists themselves met more frequently and reanimated the somewhat apathetic scene by group activity. There are new elements in Moore's sculpture. The *Half Figure* in the Robert Birley collection at Eton is carved in alabaster which is veined so strangely that the shape acquires an inner mystery. But even in 1928–29 glittering stones had appeared, forms that were wrought in esoteric variations. In the versions of Mother and Child and the Half Figures of 1931, this proliferation grows and completely upsets the figural mass, putting a great strain on its compactness. Alabaster is frequently used, so are various sorts of wood: box, beech and African wood. Materials are either exotic, or else they are worked till they act as sharp corrosions of volume. In the *Composition* of 1931, in the collection of Miss Mary Moore at Much Hadham, the complexity of aggregated, shell-shaped masses reminds one of Picasso. Read thinks it may relate to the project for a monument which Picasso had done in Dinard in 1928. Alfred Barr's comment is also interesting, that Picasso's work shows the influence of the painting of Tanguy and Miró. The sensuous slowness of its organic development which is evident in Moore's work is quite close to the 'naturalising' fantasy of Miró. But a comparison with Picasso, which may be made in several works by Moore, enables us to discern the most noticeable characteristics of his own serious, contemplative soundings. Picasso's drawing *Bather project for a monument,* 1927, was an ironical exploitation of constructive and organic elements. The sculptural composition of the *project for a monument* shows esoteric and extravagant effects in its alternate and sudden swellings and its aggressive trajections through space, which cut it up, curtly and decisively, with its formal angularities. Moore expresses his taste for the round in a tactile accumulation that increases and expands in an envelope of fruit and ovoid forms. And these conduct a fascinating dialogue with reminiscences of archaic art and the renewal of the symbolic reality of the material. 'The meaning and relief of the form itself probably depend on the innumerable associations of man's history. For example, circular shapes express an idea of fecundity and of maturity because the earth, woman's breasts and many fruits are round. And these forms are important because they have this background to their usual meaning.'

When Moore turns to compositions akin to the decorative arrangement of pseudogeometrical motifs and sectional masses, such as Lipchitz had studied in 1925, he produces a curved, upside down articulation that refreshes fixity in space and in centres of gravity, as in the lead *Reclining Figure* in the Zimmerman collection in New York. The central mass is opened up in a cavity crossed by rays—a kind of prelude to the strung figures of 1937–39.

Pl. 2

What gives this emphasis as a more complex treatment of organism and constructivism is that, despite its decorative aspect, the inserted cross-sections, although serving as subdivisions of space, strike one as extraneous elements. That is to say they describe the spatial contour within the processes of the organic matter which generally moves in continuous, intuitive waves. We may well note that at this particular moment of friction Moore increased his graphic output. Pages of drawings and watercolours of 1931 are connected with the jointless root of the Reclining Figure: so are a series of Standing, Seated and Reclining Figures in which we seem to be aware of an agonised search for unity in the figural shape which assumes new structural relationships. In order that the trajectories of the new elements should not remain extraneous, Moore executes drawings and plans for 'string' sculptures. He encloses the clefts in triangles of shadow, perforating cavities, and thus adapts the new linguistic possibilities discovered by others to his own dimensions and purposes. The continuous lines and variegated markings are intended as experiments with the rhythms of his material and are realised in the drawings of those years in such a way as to reveal the whole range of countless plastic ideas that were sculptured only later. The *Ideas for Sculpture*, a sheet of 1932 belonging to Mrs Irina Moore; *Heads*, the property of Herbert Read; and several Reclining Figures realised in montage drawings in 1933 – all these begin to clarify the expansion of the figure. This was constructed in simple, subdivided trellis work which indicates huge, distant strides in space.

Some of the curves of his lines-in-space remind one of Nicholson. In 1931, some more Reliefs appeared with short convexities joined at their point like fermentations in space. The idea seems to have kinship with the mysterious excrescences of Miró, and with the paths followed by Lucio Fontana at more or less the same time.

It was during the years 1933 to 1939–40 that other new features appeared in Moore's work. But these represent a development of utterly original archetypes, rather than a complete break with fundamental principles. We have to compare them with earlier and contemporary works by Arp, Ernst, Picasso, Giacometti, and the movements of Constructivism and Surrealism. But these comparisons always remind us of the singleness of his aims, of which he was now aware. They also remind us of the importance of matter to his forms, for we can always discern in it the activity of vital, original impulses.

All the same, his sculpture was enriched by a greater urge for experimentation. In 1933 and 1934–35 his 'form' becomes oblong, in strange cocoons. Even the Mother and Child is modulated and perforated. From 1930 Moore and Nicholson lived and worked side by side in studios in Hampstead, London, where Barbara Hepworth was also working. They both believed in employing the linguistic methods that derived from essentialist, abstract or constructive experiment as a means to further the intensification or sublimation of three dimensionalism in an imaginative way far beyond the vigorous limits defined by visible textures.

The perforated rocks, the strange, smoothed shoulder blades and curious types of reliquary-busts; the hatchings and open buds that proliferated in Moore's studio are probably the result of an intense treatment of 'Surrealist' forms. But the way they swarm in space expresses a realistic mobility and stems from the eccentric births and growths that are possible in natural as well as artificial reality. These works are called simply Carving, Sculpture, Form. The Reclining Figure appears too, in drawings, stone and even concrete (Washington University, St Louis, 1933). This stretches out like a prophetic fossil, or it is enclosed in an esoteric body, like a votive lamp, a sarcophagus or some other kind of receptacle.

The moving symbols of Arp, that were already humanly realised, are perhaps the closest analogy to these new variants in Moore's organisms. But these animated canopies, which are full of internal resonances, from inside the hollowness that proclaims them living events, are impregnated

with a disturbing quality which, in its psychological and operative fluidity is of quite another kind. The actual work on the material in all its care and precision condenses the vital currents under a tense exterior, thus creating a strong sensation of the reality of the forms. Moore studied the association of shapes fundamental in nature, as revealed by science; amoebic growth and embryonic nuclei enlarged his field of perception and sensation. Moore may also be likened to Arp and Ernst for the rich absorption of recent knowledge which gave him liberty and heightened sensibility in his interpretation of reality.

In 1934 Moore executed essential sculptures, slightly scored with small marks and perforations. They are in two or three forms. The matrix is divided into two or three cells, but the distance between them establishes various relations with space. By reducing their mass to a few nuclei he permits these pieces to set up organic refinements and 'metaphysical' subtleties of connection. The most pronounced influence on them was probably Brancusi. Nicholson and Hepworth who had just returned from Paris brought back most vivid impressions of his work. And some of Moores pieces are of the same family as some of the works that Barbara Hepworth had been completing in the early thirties with a much closer stereometric vision. But Hepworth's forms are chiefly interesting for their fascinating play upon light and air which is always present as an essential component as is the delicate modelling of the material. 'Delicacy is annate in the spirit of Barbara Hepworth, who is always logical in her harmonious contours and faithful to herself.' Moore too was absorbed during those years in almost

a fetish for material, but the individual properties of matter are always made to follow the undulations and tensions of the bodies of the moving symbols.

The manifesto Unit One

It is symptomatic that the programme and propositions published by Moore in 1934, in the volume called Unit One edited by Herbert Read – the 'manifesto' of the group – are elaborations rather than new assumptions of his own researches. The chapters are headed: 'Truth to Material', 'Full Three-Dimensional Realisation', 'Observation of Natural Objects', 'Vision and Expression', 'Vitality and Power of Expression'. These are the qualities of fundamental importance to sculpture.

The passage that talks of form as full spatial reality is of significance. Sculpture that works with surfaces cannot achieve the full power of expression that it might attain to. Here the conviction comes from a logical comprehension of matter and its potential as well as of the part played by the sculptor in realising a 'full formal existence' through masses of various dimensions conceived in their entirety. This is 'surrounded by air that impinges and presses upon it and unites the spatial relationships or sets them in opposition to each other'. The affirmation of his concept of asymmetry explains his partiality for organic rather than geometrical growth. 'Organic forms, even although they may be symmetrical in their fundamental disposition, lose their perfect symmetry when they react to environment, growth and gravity.' But in Moore's thought even this 'law' is connected with interest in all the forms present in nature, which enlarges one's formal knowledge and permits one to penetrate deeper into the unknown levels of latent energy in nature. This energy conveys the life force in all matter both universal and individual and is present in anthropological as well as cosmic space. As yet it is still unexplored or it has been rejected by classical art as outside culture according to their notions of naturalism. When he speaks of vitality Moore again takes pains to define that he does not mean 'a reflexion of the vitality of life, movement, the physical action of acrobats, dancers and so on but the presence in a work of contained energy, an intense life of its own, which is independent of the object it represents'. Here he is acknowledging abstract principles, but as the equivalents of multiple forms included in the astonishing, ample developments of types, rhythms, elements and growths that exist in the vastness of the real. A work must not aim to 'reproduce natural appearances', but neither must it be 'an escape from life'.

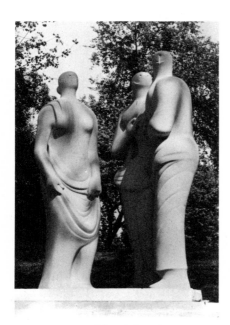

10 *Three Standing Figures* 1947–48, Darley Dale stone Battersea Park, London

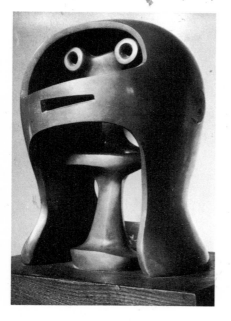

11 *Helmet Head No. 2* 1950, bronze (9 casts) National Gallery of New South Wales, Sydney

The serious attention he gave to choosing material, and his use of it in accordance with the latest abstract or constructivist theories, are evident not only in the materials themselves but in Moore's mastery of them. The result of his rich encounters with other artists and their exchange of ideas has a most decided effect in his more refined, cerebral version of the twin figures coming to birth, one in the hollow of the other, slowly extending into space with tentacle-like movement. Moore develops the penetration of form. Signs and graffiti will always be mysterious messages. But now he perseveres with a more insistent research into the correspondences between organic nuclei and open, perforated forms. The *idola fori* are used as penetrating linguistic symbols in sculpture. Moore's own comments define the actual visual and psychological values of holes in sculpture. 'The first hole made in a block of stone is a revelation. This space connects one side with the other, immediately transforming them into objects more representative of the three dimensions. A void may possess as much formal sense as a solid mass.' The mass is thus made evident and can be passed through by the senses and imagination; the hollow opens up a different space and permits us unlimited travel through it. Moore's forms have circular contours and echoing hollows. The sculptor becomes aware of other dimensions. Later he explained that during this period the hole usurped the body and utterly annihilated it. It was an altogether singular response to abstract and Surrealist experiments, which were just then influencing the works of most Anglo-Saxon artists. Sometimes Moore's figures are quite clearly

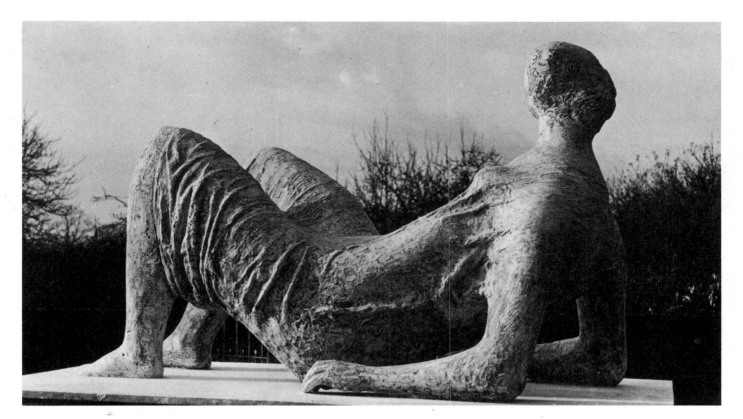

12 *Draped Reclining Figure*
1952–53, (plaster model for casting in bronze)

connected with the 'objets dad-art' of 1919 or Max Ernst's *objets trouvés* round about 1930. But his inclination always leads him to more embryonic forms, to 'form in the void, the very limits, in fact, of penetration into the primary forms of "nature"'. In his writings of 1934 his easy narrative disposition is clearly revealed when he emphasises some of the qualities that are present in natural forms, the observation of which stimulate him to continuous discoveries, 'saving him from working only by formulas'. But natural forms, the basic matter itself smoothed by nature, offers the sculptor suggestions for construction, not mere parts to be imitated. Moore strongly feels the duty to make, to produce something even where he seems to resort further back to the 'found' rock, the stone with its own form, or to the automatic extraction of which Ernst talked in those years. He almost achieves Arp's modelled 'concretion humaine', and the organic flourish of his instinctual rhythms. (In 1932 Arp began a torso, the first of the 'utterly round' sculptures, and in 1933 he made *concrétion humaine* with two softly plastic, visceral forms.) Moore's works always evince a great urge to growth, a genesis actuated in the material which is curled round, divided up and uttered with sorrowful meditation. This urge spreads out in space to recognise it and imprint itself upon it, to dwell and be alive in it. Moore is more of a teacher, not so much a fantasist or poet, but with the disposition and the results of a great narrator.

The way he manages to synthesise the stimuli of Abstraction-Creation and the various ideas of Dada and Surrealism is typical of a high level of intellectual as well as emotional confrontation and is outstanding in English artistic circles. Haftmann rightly described Surrealism in England as 'a particular phenomenon'. Read was already outlining a vision that differed from Surrealism, that left aside 'truly Surrealist aesthetics' but brought to light the romantic concept of creative impulse as opposed to *a priori* order. A group of abstract painters was formed under Fry's influence (Pasmore, Moynihan, Coldstream, Hitchens, Graham Bell) with a show in 1934 at the Zwemmer Gallery. Some years later a constructivist group was formed. Read, who was in touch with all the groups, proposed ways of resolving their oppositions and maintained that it was a good thing that there were so many experiments. Although Read admitted at one time to finding himself 'in the position of a circus rider with his feet planted astride two horses', he always believed that 'similar dialectical opposites were good for

the progress of art'. He also thought that 'the greatest artists' (he meant Moore above all) 'were great just because they were able to resolve such oppositions'. On the other hand the analysis of Moore's work shows how difficult it is to isolate its influences and count the programmatic antecedents that never became permanently incorporated into his vision.

Figs. 3–8, Pls. 2–9

It was not by chance that in that decade, 1930–40, in being aligned more closely with European experiments, Moore's sculptures meet the innovatory developments of Arp, Ernst and Giacometti at their highest peak. These were all artists who did not believe, in practice, that any formal system should be their criterion or sole guide. They had given and were still giving positive, practical support (even more than they realised) to Dada and Surrealism. Even the abstract principles that Moore mentioned in his manifesto in Unit One (in the title of which was combined the idea of unity with that of individuality), even these were not far removed from the characteristics of constructive drawing that he had already absorbed in his early years, following Fry's ideas. Abstract principles are present in all great art; they helped Moore towards the realisation of his idea, 'which acquires a human, psychological element too'. The abstract and human components must be founded on a deeper penetration of reality. 'Because a work does not aim at reproducing natural appearances it is not, therefore, an escape from life, but may be a penetration into reality, not a sedative or a drug, not just the exercise of good taste, the provision of pleasant shapes and colours in a pleasing combination, not a decoration of life, but an expression of the significance of life, a stimulation to a greater effort in living.'

The interesting process adopted by Moore in *Carving* and in *Square Form,* and in other simular works of 1936 (the former in the Sainsbury Collection in London, the other in the Wal in Amsterdam), may lead to a comparison with some of Giacometti's sculptures such as *Couple,* the Heads of 1926 or *La Tête Cubiste* 1932–34. But Giacometti refines the hollows and geometrical reliefs on his surfaces to excess. He feels space spreading out and fleeing away, enormous, distant, with slightly curvilinear edges. Moore, on the other hand, covers the surfaces of a block of stone with reliefs, grooves, tracks and protrusions, in order to achieve three-dimensionality and thus space. He finds the figure there, squared and flattened as if it had emerged from some powerful press, but pulsating beneath its geometrical passages. Their rhythms are like the gently perforating, cutting bars that mark the contemporary painted reliefs of Nicholson. But in Moore's massive marbles they are the veins and channels of an organism that subsists and pulsates, despite the pressure, within the external planes.

There are Cubist elements in the works like *Square Form*. But, just as had happened in Nicholson's works, so in Moore's that linguistic influence served 'to extend it in quality, to select and reduce it in quantity' (Argan). Those very closely serrated lines in which the figure is enclosed serve to establish other parameters of direction, of leading the material into space. The result achieves the solidity of an architectural block with internal features, which is the inspiration of many successive sculptural expressions both in Europe and the USA.

There are clear traces of this new, important facet of linguistic and expressive energy in the elmwood *Reclining Figure* of 1936 (now in the City Art Gallery and Museum, Wakefield). There is a yet more finished relation between internal and external space. Moore analyses the structures even more deeply two years later in a Reclining Figure destined for a particular location. He was given the opportunity by the architect Serge Chermayeff who wanted a sculpture for the terrace of his country house in Halland, Sussex. Moore at the time was in contact with Gabo and Gropius, and engaged in discussions about the relation between sculpture and architecture initiated by the Constructivists. Some of their theories coincided with his permanent belief in the anatomy of sculpture. The capability, or rather the duty (Pevsner), of sculpture is to mediate between the building and space, but in fact this argument stimulated Moore to make sculpture a

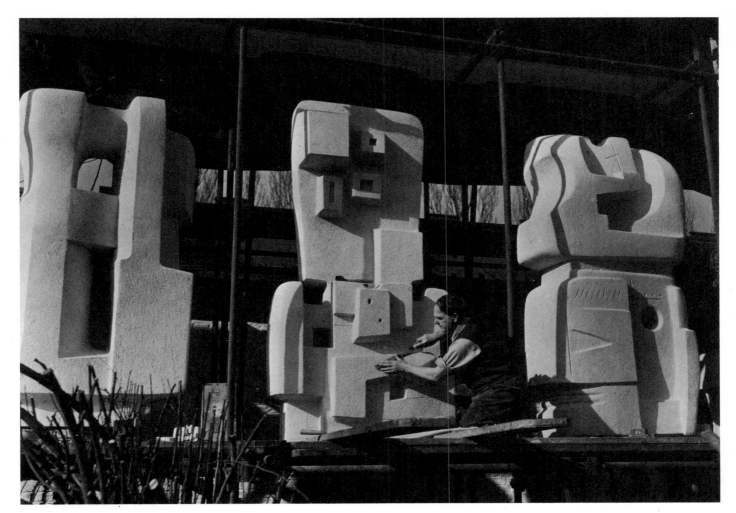

place and space of its own and to make it efficacious for other values. The intrinsic values of organic sculpture were in his opinion more suited to the open air, to the reality of space, nature and the earth. Open air sculpture, for reasons connected with his fundamental ideas, needs and experiments, was to become not only a recurrent theme in his statements, but the origin of and stimulus to transformations in the Reclining Figures.

Earlier, in choosing a Reclining Figure for Chermayeff's terrace, he had studied the logic of visual relationships on the site. He had rejected the idea of an upright figure such as the architect had requested because such a figure would have 'introduced a useless drama' since the building's foundation line was horizontal, and afforded an open view across the winding banks of the river. The *Recumbent Figure*, on the other hand (the sculpture he produced for Chermayeff in 1938, now in the Tate Gallery), came into being as a focal point for all the horizontals in its utter formal and structural autonomy. The typical physiology of Moore's extended figure is endowed here with the fullness of a matrix both simple and complex at the same time, so that it makes an immediate impact in its psychophysical entity and suggests other allusions. It displays a clear, imposing architectonic organisation which controls its organic being. In other words it is instinct with a quality which is most striking in Moore's archetypal images, the sense of the numinous, a noble feeling of distance from incidentals, and from human and formal naturalistic minutiae. This characteristic is intrinsic in the constitutional, formal and aesthetic strength of the work. 'In this sense, the work of an artist of Henry Moore's seriousness is always religious: though it is not necessarily Christian or sectarian but rather mystical (the theological word numinous might be more exact)' (Read).

These Reclining Figures stretch out in the open space of landscape. They are part of the place, and continue its shapes in the shape they have, that of great knotted trunks. Sculpture in the open air needs to be larger than life: it loses part of its effect by exposure, and of its attraction, surprise and

13 Henry Moore working on the *Time-Life Screen*, 1952–53, Portland stone
Time-Life Building, London

Fig. 7

fascination. The hollows get bigger and the great sweeps and prominences swirl around in huge waves and the holes in the high heads look into the distance. This is what animates the vast, anonymous body, spread like a mountain, alternately rising up yet bound to the earth. 'My sculpture protruded from a hump in the Downs and its gaze reached the horizon.' The Recumbent Figure, in short, took no notice of Chermayeff's building. It strove for an identity with different dimensions and with the forms of the earth. It had no need to be on the terrace of the villa. Yet its presence introduced a humanising element, a meaningful mediator between 'the modern home and the ageless land'. This relationship, so concisely defined, was to be explored with ever increasing mastery. But actually Moore's work is so closely and studiously related with basic forms of Mother Earth, her richness and mystery, and her 'nature', that diffused 'other' material tends to become confused with the earth itself.

Stringed figures
Pls. 4–6

One of the more perplexing experiments in Moore's development was the construction of Stringed Figures between 1937 and 1940. Picasso had produced caged figures about ten years earlier. 'What strikes one in both cases is their sinister, mad quality' (Giubbini). But Moore's experiments seem to have originated more comfortably, with rhythmical, narrative, rather than polemical, stimuli. His types are bursting with metaphysical tensions, particularly in the version they assume in his drawings of this time. These modes, as he later explained, were inspired by his memory of others exhibited in the Science Museum to illustrate mathematical propositions. But his constructions, in free paraboloids, retain a disturbing character just in the contrast between the weight of their organic parts and those traversed by stretched cords. There is a contrast between matter and geometry which, in the earlier versions, leaves the symbolic value far too obvious (as in the Mother and Child, where the cords tie the child to the mother's belly). Yet this is the moment that Moore calls the most abstract of his whole career. Certainly it indicates a corroboration of Gabo's ideas, of Pevsner and the notions being prepared for the publication of *Circle*. But Moore shows, through all his constructivity, persistent interest in a Surrealist version which reaches its peak in the drawings of this period. On the other hand his lack of interest in taking up a decisive position about either Surrealism or abstraction is fully reflected in these pieces. Moore, like Nicholson, Hepworth, and Nash, who were working with Herbert Read, reveals a capacity for reaction to, and comprehension of, continental experiments which is amazingly acute. In 1936 these had been seen in the wide-ranging, wonderfully rich panorama of the great International Surrealist Exhibition. They have also been propagated by personal successes in shows and in some of the typical, most daring reviews representing the avant-garde.

It was in the catalogue to the Surrealist Exhibition, and in a volume of essays entitled *Surrealism*, that Herbert Read set the new influence and new poetic in a historical context that clearly lessened its impact. However, it did involve instances from the past (Blake and the English Romantics), and exposed the literary and aesthetic roots that fed living English artists. Hence it was easy to reach a positive acceptance of Surrealism, but it also provoked interest in the properties of the instruments of perception which had been contributed by Abstraction and Constructivism. This did not happen without great argument and differences of opinion among different groups. Geometry and constructivist reconstruction were not accepted literally by most people but the ideas of Gabo, Pevsner, Mondrian and their followers were understood in the full significance of their theory of cognition and operation. They seemed a positive vision of the social functions of the aesthetic process. But Surrealism certainly proved a strong attraction, chiefly because it upheld 'the primacy of the imagination', as Read declared in his rejection of unbridled fantasy, chance impulse and automatism.

The great English artists clearly saw the possibility of adapting Surrealist elements of incident and abstraction in an entirely autonomous way. That is why Moore's sudden use of strings in his drawings and sculptures remains an idealogical moment. Although attracted to Surrealism Moore protested that the figure should not be seen as a 'little wax manikin', and rejected everything that tended towards montages of the *cadavre exquis* kind. If anything it is a sort of metaphysical transformation, involving bizarre figural elaborations inserted in a dream space that we see in the drawings of 1937–39.

On the other hand, in an article in *The Listener,* Moore declared his distaste for the arguments between abstractists and Surrealists; he thought them a waste of time. 'All good art contains abstract and Surreal elements together, just as it contains classical as well as romantic elements; order and surprise, intellect and imagination, conscious and unconscious.' And in an article in *The Circle* he reaffirmed his conception of art as being not imitation of natural appearances but rather (as he had stated in *Unit One*) the opportunity for new penetration of reality and as 'stimulation to a greater effort in living'. When he has to express opinions on architecture Moore sees that it has limitations, connected with its functional aims. Sculpture, by contrast, may freely explore the world of pure form: that is, it may make use of every material and structural process and 'more naturally than architecture can use organic rhythms'. Moore, like Nicholson and Sutherland, thinks it unimportant where the urge to experiment comes from; whether from the act of drawing 'lines and tones without an exact purpose' or 'from a pre-determined subject such as a sculptural problem that one has set oneself'. What matters is the knowledge that is acquired during the work in progress, a period in which there can be great 'leaps of thought,

or the intervention of associative psychological factors . . .' But the automatic impact of information is proportionate to the extent of attentiveness that guides the artist during execution, while he is handling his material. There may be psychic urges, unexpected illuminations, but some conscious idea must then begin to emerge which crystallises at a certain moment '. . . and then control and order begin to intervene'. In some ways Moore considered the organic world (or rather its difficult transformation into a sculptural image) according to requirements of method that are truly scientific and rational although its actual process and fruits had to convey expressive responses to memory and impulse.

Generally, Moore found himself in agreement with Constructivist principles even if his sculpture is at the opposite pole from the aesthetic ideal expressed by Gabo and his like. In the thirties, however, some of Gabo's innovations were perfectly acceptable.

Gabo, as Herbert Read had recently pointed out, affirmed that: 'The abstract is not the central nucleus of the Idea. Constructivist I may be, but the idea means much more to me. It implies the whole complex relation of man with life. It is a way of thinking, acting, perceiving and living. Every action or thing that elevates life, drives it forward and pushes it in the direction of expansion and growth is constructivist'.

Read's comment of Gabo's theory of the ontological function of constructivist sculpture sheds considerable light on the conception that guided Moore. Gabo's definition tended to emphasise its scientific fecundity on the basis of the fundamental principle of 'conquest of the real', by which we mean the discovery of new images to represent the nature of this reality as it is revealed to the artist's awareness. Thus art is parallel to science. It moves, however, by intuitive preceptions of the nature of the physical world towards new and ever more precise images to embody these intuitive perceptions. The artist's images are concrete, that is to say, materials of construction that project the mental image as a kind of icon of universal significance. Read even found in Dadaism those statements that most closely agreed with the conception of art as positive, not destructive. The least revolutionary and most creative statements, in short, were selected in the world of the English artists, that was largely open to procedural experiment and participated intensely therein. Even certain of Arp's theories and instances were transmitted through Read's formula. Arp said: 'I have sought to be natural'. And Read paraphrased with, 'In this effort lies the revolutionary meaning of Dada since being natural must indubitably be the same thing as being faithful to nature', but on the basis of a total liberation of creative impulses. Towards the end of the thirties Moore reaches the most programmatic point of his constructivism. But his penetration leads him to perceive how mastery can be worked out as the point of contact between organic reality and the abstraction of form.

In 1937 he attached strings to a relief (the *Stringed Relief* in the Pritchard collection, London) and to an upright form sculptured in wood. The next year he produced other pieces, some in plaster, in which he developed the Mother and Child and Reclining Figure themes. Then he cast them in bronze, substituting metal wires for strings. The only exception was *Bird Basket* in guaiac wood, and all the others were meant to be cast. Although the technique is complicated at times, it is clearly related to the implied transformation of formal idea into symbolic values. Thus it was not merely an experiment with the relation of organic and constructive. When these sculptures were cast they acquired an intense gravity far beyond that of similar works by Gabo, Hepworth and Pevsner, and this gravity contains metaphorical allusions which grow with the actual reality of the work's paraboloid twisting. The original plan thus takes on a strange, heterogeneity which is increased by the exploration of dislocated and almost self-moved forms, such as appear in the drawings, from which even in later years Moore was to derive many further ideas. In the graphic work of this period we note how often there is a difference, between Moore's

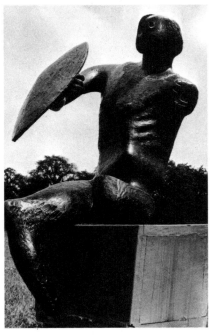

15 *Warrior with a Shield*
1953–54, bronze (5 casts)

Pl. 4

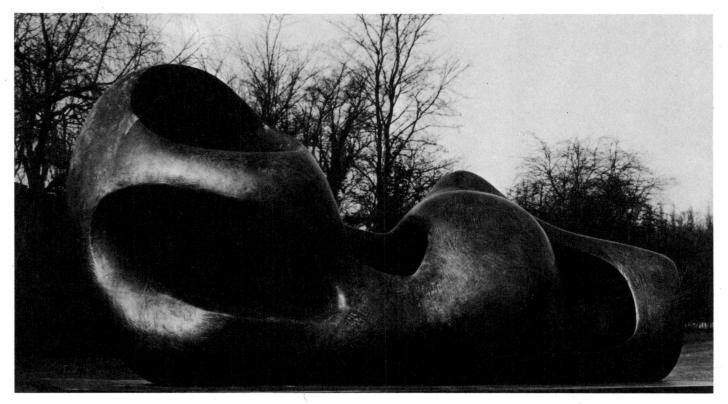

16 *Reclining Figure: External Form*
1953–54, bronze (6 casts)

sculpture and drawings, in the constructive and iconic content which certainly indicates an enlargement of interests but also gives a more fruitful account of the psychological and constructive pattern that supports the work and his vision. Up till at least 1950 Moore's drawing shows an intensification of the narrative as well as experimental elements. And in the settings of 37–39 we find detailed scenes once again, composed with the maximum development of space. His parallel works of sculpture are born from selection from one of the living forms in the drawings' settings. That is why the stringed figures have such intense visual and psychological ambiguity. In these the organic part is perforated with absolute cavities which are then crossed by webs of strings. The contact between organic re-entries of the material and the strings expresses not so much a topographic exploration – such as is explicit in Gabo's or Pevsner's sculpture – but an anthropomorphic ambiguity. It is not by chance that the titles of these pieces still allude to figures. But whatever variant Moore adopts, naturalness always colours its artificiality. His 'alchemical change' produces things that are disturbing because they seem alive. His objects appear to have been created by inspired craftsmanship. But this impression is misleading. These objects are animate. They have hooked peduncles and crutches, like characters in a ghostly performance of a work *à la* Beckett.

Ghostly dialogues

At this point, and especially in relation to the drawings for the stringed figures we may mention the metaphysics of De Chirico. There is a great similarity in atmosphere but it relates to the general impression rather than profound concord in their inner visions. Shadows of an undefined sort curl around Moore's metaphysical areas and these have certainly been finished in the light of a sterner view of Surrealism. By contrast De Chirico follows the direction of his contemplation, fixes his dreaming vision on the apparition which is removed, but not actually different, from what is in front of his eyes. The place, architecture and figures are ennobled in form. The setting and the objects detach the thread of time in a suspended moment of space, utterly without the breath of life. The enigma broods over the things of mankind.

Moore pursues a dimension that, in its evident visual concision, unleashes a kind of 'life extraneous to human consciousness', yet endowed with some sort of human consistency, an absurd but possible metamorphosis. It is the

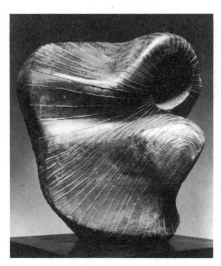

17 *Head: Lines*
1955, bronze (7 casts)

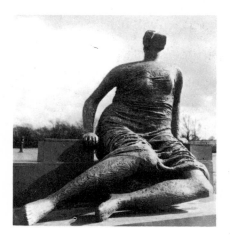

18 *Draped Seated Woman*
1957–58, bronze (6 casts)

same 'secret immediacy of a figure rising in a room or in the shadow of a hedge . . .' of which Sutherland talked. In Moore's drawings the figures multiply and spread out in the enclosed spaces of their setting like specimens from another world. In the 'drawings for metal sculpture' we hear the conversation of ghosts who recall Picasso, especially in his anatomical drawings of 1933. They are solidly constructed, however, with a grave objectivity which has none of the 'sensual and grotesque' (Giubbini) expression of Picasso's form. In fact they establish a pattern of models, of horrible reproductions that are born through the mysterious creativity of biological and cosmic matter. The curious aspect of these fantasies is how enormously they take advantage of the sculptural pieces already produced in the workshops of Arp, Brancusi, Archipenko, Ernst, Picasso and Moore himself. Here they are transformed into sententious objects in the same way as rocks, bones and cords, and armour moulds for the sculptures. Once set in their scene, they withdraw to a critical distance, somewhere between black humour and *Angst*.

Even the colour of the drawings is pervaded by a quality of alienation, which lies in the heteronomy of the figures. Thus the pages packed with plans for an extended figure in metal are filled with a profusion of intaglio, and the density of the carving on each figure is expressed with an almost obsessive insistence upon the mark, upon the webs of the hollows and their corrosive exploration. In short, we seem to be watching a technical exercise devoted to prophesying a scientific discovery. The crowds of skeletal figures (like those in the 1939 series of sketches for a Reclining Figure in the collection of Mrs Benjamin Watson in New York) are like a vision of the human mummies in the underground that Moore was to portray in 1940–41. Moore always works from a desire to revert to the root of things, and to their essential quality, out of which he digs his own enigmatic world and uncovers it without irony or mental contortion. Here Argan's comment, when comparing him with Picasso, is relevant: 'Picasso abridges and burns up the history of centuries. Moore wastes nothing, making use even of the splinters and relics of a lost history. In this raw stage of the world Picasso is the cricket, Moore the ant. And the world, after seeing its own end in Picasso's dark mirror, holds out its groping hand to the basic mental aids, and the inviting Freubelian toys that Moore the craftsman has patiently carved and smoothed for its second childhood.'

As for the Constructivist experiments, which certainly attracted Moore, the development of the stringed figures results in a fantastic alternative. The pseudo squared figures, of a general paraboloid or elliptical type, are repeated with derivatory variants, with several folds and articulations that create changeable relationships. The hollows and fullness of the organic parts still predominate. If the strings set up a transparent barrier that creates 'a contrast with the curvilinearity and density of the solid parts' (Sylvester), the organic element still emphasises a somewhat embryonic internal movement. This is what gives these sculptures an animistic, magic character. Object figures emerge from Moore's witches' cauldron that are a yet further development of the archetypal symbols. They seem to have been transformed once again in a way that belongs more to alchemy than to 'the realm of technique' (Neumann). It is this alarming element of superhuman vitality that constantly lifts Moore's sculpture out of peaceful co-existence with the projects of any avant-garde. Certainly the connotations touched in these experiments have visionary force, a perceptible allusiveness to science fiction that was more advanced than any successive researches. The creative power he achieves in the drawings, in the balance between a frightful prevision of metamorphosis and the gnomic solemnity of the actual apparitions is the outstanding quality of this phase. Even in the sculptures there is no decline towards mere perfection in craftsmanship.

Form and space as a continuum

However interesting the stringed figures, Moore does not dwell on them. Later he said that it was a kind of ingenuity to go on producing them.

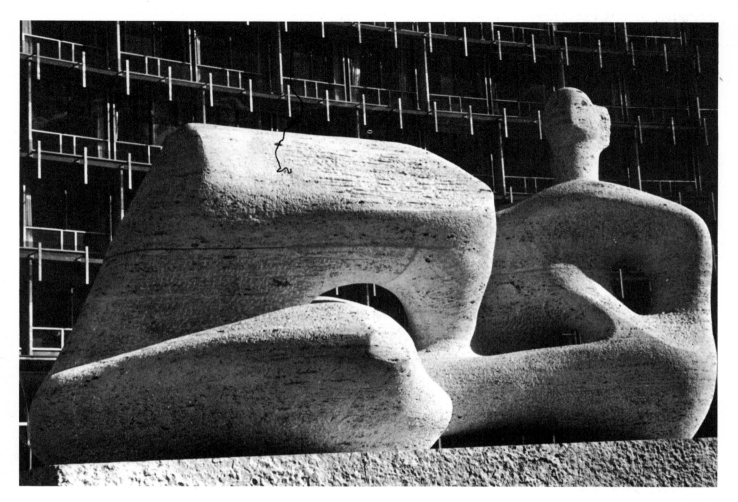

19 *Reclining Figure*
1957–58, travertine
UNESCO Secretariat Building,
Paris

Pls. 7, 8

There is a great advance in his study of the space-matter relationship between the Reclining Figures of 1936 and the Stringed Figures of 1937–39. His montage of organic form and constructive tensions made keener the penetration of forms integrated with hollow spaces. Now, between 1938 and 1939, the torment of the hollow assumes a paradigmatic reality in the stone Reclining Figure and the elmwood one at the Institute of Art in Detroit. They are both executed with complete mastery. The significance of the perforation had reached its highest expression, that 'mystery of the hole—the mysterious fascination of caves in hillsides and cliffs', of which Moore often talked. It was more than a comment on hollows and solids in sculpture. In his view sculpture could not be a relief of profiles and silhouettes but a work that develops 'from its internal centre towards the outside'. Moore's ideas and his application of them continue and emphasise the explorations that Archipenko had conducted in the relationship between positive and negative, concave and convex, means whose aim was to open up the volume and point out its internal prominences. Already we are far removed from the conception of sculpture as a 'science of voids and bodies' and even the ideas of three-dimensionality that had stirred Rodin. But not even his theory gave sculpture 'the significance that it demands' since 'hollows and bodies do no more than describe surfaces themselves'. Moore thought of form and space as an inseparable continuum; together they reflect space in its globality as a 'malleable material element' as Gabo described it in the *Circle*. Those great openings, then, in the Reclining Figure help us to gain a simultaneous perception of every thrust and withdrawal of the form, 'connecting one side with the other' (James). But the hollow has another power too: that of lightening the positive weight of the mass, the 'entirely circular' volume that might otherwise tend towards closed monumentality. Now the hollows become elements of a profound organic architecture. They reduce the volume, yet build; as they build they extend the form's structure in a multiple asymmetry. The asymmetry Moore so often spoke of did not refer to geometry but to organic growth. It is a value

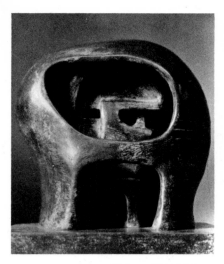

20 *Helmet Head No. 3*
1960, bronze (12 casts)

of growth and formless tension which nevertheless achieves form, and it is directed independently of the sculptor by the pressures within the material and between it and him. Asymmetry then is the irregular evidence of internal spasms and the hollow throws forward these impulsive movements and intensifies them till they become the motions of a construction built up from inside. Moore's anti-geometric spirit did not overlook any chance of operating equally on material-organic form (which comprehends all the forms of the world, rock, embryo, and man) with the same attention and strictness as an architect. Through the perforation he discovered other grave, fundamental dislocations which enabled three-dimensionality to emerge as vast, articulated, internal-external architecture. Each encounter with a 'figure' brings further surprises. 'A block of stone can carry a hole and not be diminished by it; if this hole is of a dimension, shape and significance calculated according to the arcade principle, such a block stays just as solid.' His rejection of the monumental, sometimes laborious, and stentorian, is persistent. It speaks in a profusion of sensual symbols, the response of emotions aroused by the body. 'The feeling of menhir, the memory of rocks that stick up from the sea' also sets these Reclining Figures in confrontation with the wider experiences of physical life', in that they do not concern themselves with representation of the body but with all the structures that modern man knows.

The conflicting memories that are present in Moore's Reclining Figures – the sculptural body that is growing here and now, and yet recalls distant iconologies, of nudes like the Dionysus and Ilyssus from the Parthenon, of pre-Columbian idols – take new blood from the pragmatic, efficacious image of the sphere of mere action to which Moore was so wholly committed. He also pointed out human value, noting that mere action, in order not to be the final crisis of conscience, required a moral justification for it to re-open to the world of men their closed views of the world of nature. This is Moore's new humanism, inspired by the ideology handed down by Ruskin, Morris and Fry. This reinstated medieval mechanism against the liberal art of the Renaissance, the tradition of technical processes as opposed to that of forms, and experience through action against experience through history. He thus succeeded in squeezing out of matter a new spatiality which stems from the trusting presence and laborious action of men in the world, and from their continuous inexhaustible forming of the world in which they live (Argan).

The shelter drawings · The intense mastery of ideas and structures that Moore showed in the drawings of 1937–39, which emphasise his own individual inclination and reveal complementary ideas to the temporary string figures, led the way to new investigations in the now famous series of drawings he did during the war. The shock he felt at seeing the long lines of figures sheltering in the tube stations in London renewed his interest in the human condition. But we should note at this point that the real stimulus to the shelter drawings came from the surprising relationship Moore discovered between external reality and the obsessive leit-motives of his sculpture.

In the London tube during the air raids there appeared long, agonised rows of reclining figures, of mothers and children, of seated single or grouped figures. The pictures of the people who defied the authorities to live in the underground form a series of solemnly elaborated graphic pages on the borderline between figures from some dream of ancient painting and the threatened space that had already appeared in the settings drawn the previous years. The *Gash in Road* of 1940 (Sir Colin S. Anderson collection, London) is enough evidence, where the graffiti of the upper wall, which overhangs the space below like some rock over a cave, are the relic of those occluded fissures, geometrical in form, that had suggested the enigmatic space around the figure-objects of 1937–39.

The shelter drawings are not from life. Moore drew them from memory and, as in all the corruscating pages of graphic work up until 1948–50,

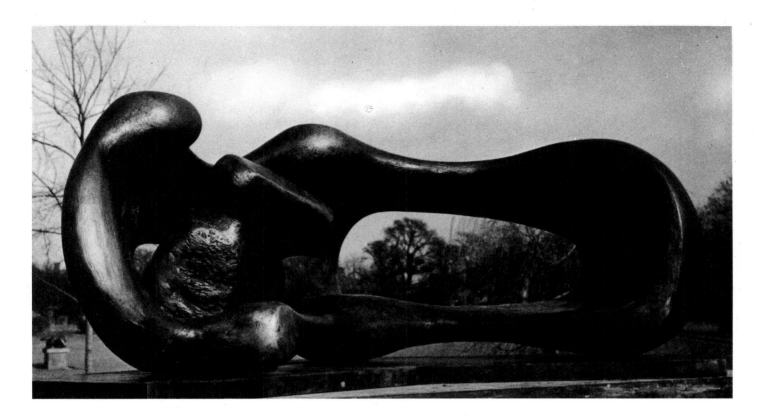

they display richly significant formal texture. Many of these pages brought
forth ideas that were to be pursued in later sculptures, from reclining
figures to *Helmet Head* and internal-external forms. Actually the shelter
drawings reveal refinements of language which go still deeper into the
problems of form, while the passages between structures and existential,
psychological events become finer and finer. A higher degree of disturbance
is obtained by the freedom and insistence of the cross markings which build
and destroy figures and hollows and contrasts. All this work, then, amounts
to a break with the graphic and sculptural work of the previous period
that dwelt upon disordered images of a surreal and abstract kind. The
spectra cocoons of Moore's refugees spread out near and far, solitary or
packed together in corners of dark space. They form into gatherings of
wasted bodies whose sinews show through. It is definitely a move from
dark, introverted archaism to attain 'the individuality of very detailed
figures, submerged in an appearance of space'.

Intensity of emotion is produced by the precise structure of the ranks of
bodies and from seeing them as images of human substance reappearing
in ghostly reality. The affinity between these figures and those that Giacometti
was envisaging at the same time may be revealing. Giacometti had gone
back to drawing, in about 1940, to halt the utter absorption, the total
disappearance of the figure. 'A large figure I found false, a small one intoler-
able; and then they became so minuscule that a final blow with a stick
would dispatch them forever into the dust.' So it was 'to halt this flight
into the distance of memory, this final vanishing into the void' that he
'went back to drawing; it was a way of fixing an image before its intense
space, the distance of time, could devour it' (Bucarelli).

Moore thought of the consumption of form in the same way though with
greater resistance to the idea of utter dissolution. It is his markings that
uphold the form like an inner trellis, a preparatory sketch for a piece of
sculpture that stands firm in the shadowy space, with a cavernous light
cast on it. The figures appear 'as if a magic lantern were projecting on to
drawings on a screen' (Eliot). Sometimes there is a markedly chiaroscuro
figure amongst the sleepers in bunks wrapped in their overcoats, and this
creates 'an atmosphere which strengthens and surrounds the forms'. This is
not a result of 'that keen, naturalistic study of surrounding atmosphere
such as some sixteenth century artists had been absorbed in. It was more of

21 *Reclining Mother and Child*
1960–61, bronze (7 casts)

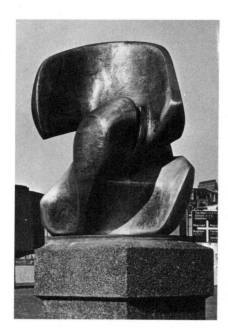

22 *Locking Piece*
1963, bronze
Riverside House, the Embankment,
London

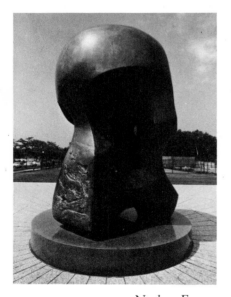

23 *Nuclear Energy*
1964–66, bronze
Chicago University

the decorative quality, which we encounter in every period of painting, by which any artist of sufficiently delicate sensibility reaches that element that coordinates the forms superficially and gives expressive tone to the work' (Fry).

The atmosphere of the shelter drawings is rather the tangibility of the mysterious sense of decay, together with that of the last chance for survival in the depths of this catacomb. 'Man has taken shelter in the earth. As in prehistoric times, he seeks refuge in its caverns, its dark galleries, tunnels and catacombs. But this time he is victim of the technical forces that he himself has called up, and that he consequently incarnates even in his laborious existence: the whirlpool, the abyss and the catacomb' (Fleming).

On the other hand the similarity that is clear between his conception of these spectral figures with their curves and reiterated lines and other drawings both earlier and later shows how wide-ranging and clear was his visual intention. As David Sylvester has pointed out, Moore had devoted himself from 1938 onwards to drawings that are concerned with more than form. The luminous areas of the rows of figures in the tube raise, in the thickening areas of light and shade, sculptural problems beyond merely expressing ones. We may remember that between 1940 and 1942 Moore did no sculpture at all. The shelter drawings gathered up all the threads and feverish tensions of his thought. There is a distinct complex of interests which at that particular moment in the war and its discomforts and disasters represents the answer of Moore's social consciousness. Here it is stimulated to explicit humanist emphasis, yet the problems it deals with are the ones that always concerned him. Expression of human values and of reality go hand in hand with belief in the honesty of work expressed as fully as possible according to his own conception. In 1940 the present and past are aflame together in suffering. The immense impression Masaccio had made during his Italian journey revives in contact with this direct view of humanity. Moore has mentioned on several occasions the severe mental conflict that this study of Italian art had left him with, particularly the frescoes in Santa Maria del Carmine, Florence. Giotto, Masaccio and the late Michelangelo ('a noble, rich-blooded maturity of strength mingled with melancholy') now stimulate him to reinforce the significance of appearances. Moore now starts to separate human value from its Surrealistic involvement, in his drawings and stringed figures. He establishes new rapport with it, and while memories of Masaccio, Goya, Daumier and Cézanne seem to influence him, the sinews of unravelled matter tell of a different evolution, like that of a chrysalis being born in a beehive, like the tube shelter perspective, 1941, in the Tate Gallery, London. In other words, the shelter drawings represent another important development in Moore's thought. The archetype receives new features, assumes more incidental human material. The *Family Group,* the *Madonna* of Northampton and the *Three Figures* in Battersea are a departure from drawing. Whether this is taken from life or from art and its devices it is true that at this moment Moore reaches some of his highest visionary flights. These are impregnated with historical sense yet are so vigorous as to minimise, when contrasted with them, most of the realist and expressionist works produced in Europe during and after the war. And they always remain a much more complex experience, that progress reveals intense involvement with operative and human progress that evidently entails the vast pressures of everyday existence. Even in Eliot's *Waste Land* new hope still flashes out.

Pl. 1[c]

Figs.

The St Matthew's Madonna

His experience in the shelters prepared Moore for a more reflective phase, instead of direct exploration of his fundamental themes. In 1943 he accepted the commission for a Madonna for St Matthew's church, Northampton. The interest it stirred in him, though somewhat perplexed, was due to the relationship he perceived between a Madonna with Child and the Mother and Son, one of the archetypes of his deepest obsessions. But while in the free compositions, he had been able to pursue freer perceptions of the

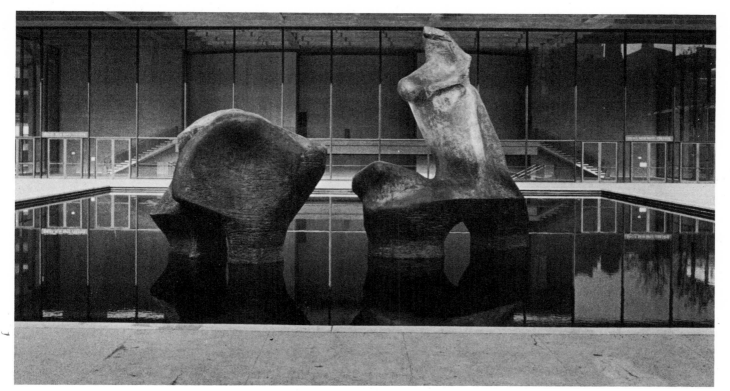

24 *Reclining Figure*
1963–65, bronze
Lincoln Centre,
New York

development of masses; here he was concerned with making the open reality of his own research coincide with the iconic attributes of an image already familiar in religious myth. Moore gave his attention not so much to the canonic forms of the holy subject as to certain symbolic elements in matter and form that might lessen 'the difference between religious and secular art' but still respond to his own basic intent. 'I began to think of the Madonna and Child for St Matthew's by considering how a Madonna differs from a sculpture that represents only mother and son.'

The difference lay, he thought, in the characteristics of 'austerity, nobility and a certain sense of grandeur (also of hieratic isolation) which are not to be found in the usual idea of mother and son'. Some terra-cotta sketches of 1943 reveal profound traces of archaism joined with a variety of tentative experiments which tend towards a more evident naturalism, that stems from the attitude of the Mother and the various psychological attitudes of the Child. Sometimes he even produced idealised types, quite closely akin to Gothic traditions. In the terra-cotta specimen in the Lord Kenneth Clark collection, these various tendencies all seem to be combined. The material moves, the mother's body spreads out and around the child as if in a deep, protective embrace and evokes the archetypal images of ancient cultures. Thus the various contributory elements in his iconography are more apparent in this humanised form and are compounded in a noble synthesis. But the historic stage that is approached and reworked through internal motion now seems to be Gothic art, still full of contrasts and asymmetries. We may well talk of similarities between both this Madonna and another one done in 1948, after a design of 1943, for St Peter's church at Claydon in Sussex, and Enthroned Madonnas by Arnolfo di Cambio and Tino da Camaino. The wood contained within her ample folds even suggests an interesting comparison with Jacopo della Quercia or with an imaginary sculpture by Masaccio.

Among the sketches made for the Madonna he chose the one that contained dignity, tranquility and expansiveness. The vividness with which they are expressed in the sculpture barely conceals the tension in the material which is compacted within and flows out with unusual slowness.

In the process of carving the piece in Hornton stone, Moore did not attempt any novelty of gesture, placing emphasis firmly on the single mass, accumulating architectural forces in the mother's body, in her legs and in the powerful bust. The left leg is slightly drawn back to allow ample

Fig. 9

movement to the forces of the drapery. Perhaps these more composed figures lack 'the element of actuality which converts their eternity into an eternity that is valid now' (Neumann). But they are imbued, Neumann goes on to say, with a sort of vitality that 'in short constitutes the whole revolutionary element in Moore's sculpture', even during those years when he was retrieving the humanist emphasis.

The concept of the Family Group

During 1934 and 1944 many works show his pursuit of the hollow in the figure in similar terms to the Northampton *Madonna*. Another important public commission further concentrated his attention on the same problem, this time a Family Group. Here again we see Moore's conflict of matter and form, material and mass, the issue of which has to encompass and embody the extraneous figure of a family of humans. But his ceaseless effort to achieve sublimity in their relation is comparable with his explorations in the Reclining Figures. The later stages of enquiry, as we can see from the sketch models and the various bronze castings, is one of the most taxing, dramatic processes created by contemporary sculpture. Moreover the Family Group was the occasion not only of further development towards a modern humanist myth, but of personal progress in the problem of matter-form.

Pl. 10 The idea of the Family Group came from an important connection. In 1936 Walter Gropius had been called in to build a school at Impington, near Cambridge. 'Gropius asked me to do a sculpture for the school. We talked about it and I suggested a family group as it seemed to me the best subject.' Moore thought of an image that was broadly commensurate with the relationship that Gropius's building was establishing with social realities. He was struck with the idea that the school was a village college where parents and children could come together. It was to contain reading rooms, projection rooms and guest rooms for other relatives. The intensity of family and social life thus encouraged was certainly a new feature in social and environmental experiment. It was to become a centre of activity for the surrounding villages. This is where Moore got the idea of a family group. But the work occupied him from the moment of its conception till that of the first casting, for a considerable number of years and in efforts that reveal his continuous preoccupation with the subject. The Family Group was an expansion of the Mother and Child archetype. Yet the graphic and sculptural plans required an almost repetitive extension of events, and alternatives of spatial gesture that might threaten the unity of the formal idea. The series of drawings and maquettes he made between 1944 and 1948, which remind us of his shelter drawings in structure, reveal his aim for a monumental composition compressed within ample, hollow revolution of bodies and exchanges, between frontal growth and the thrust of unusual masses. The parents turn slowly towards the centre. The slope of their huge knees has an architectural force. The mythical presence of the Seated Figure and of the Mother and Child faces its own double and derives from it a sense of ritual. But the unravelling of forms, which creates a vast screen of protective gestures, is in itself a concrete image of family of the highest possible significance. The father (a new feature in Moore's sculpture) and mother live in their function of protecting and caring for their children. The hollowed torsos and the pattern of laps and legs are receptacles in which the children are curled up.

Moore's intention in this elaborate work is once more to see how far material may be amassed in space to become a profound nucleus of real and human value. The alternation of concave and convex represented the unitary web of the family, connected in its turn with the unlimited web of society. In its massive, fresh solemnity, wrested from historical typology by the intensity of its carving, Moore deliberately approached the pedagogic conception that had inspired Gropius too.

The variants he had conceived in the Family Group led towards a more vigorous realisation of internal movements, which coincide with deep hollowing in the form according to structural and psychological theory.

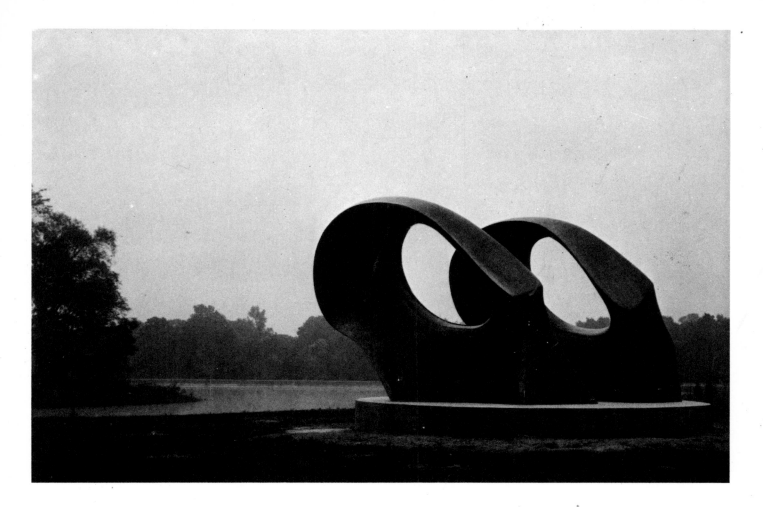

The artist's interest in assaying a more human subject had been enormously strengthened. At the same time his dealing with a historic iconology that has been repeatedly treated encouraged him towards a new image, a concrete symbol that might find its true existence in sculpture. The interest this significant form reawakened in the demands it would make on the play of his intellect and senses in daily hard work upon a material imbued with anonymity and historical richness. The shadow of the historical image seems to remain as a huge, copious cocoon. But Moore has realised an element of growth in it, an element of change that gets rid of imitation of the ideal in order to achieve the most original possible rendering, structurally and visually, which is also concretely expressive. All these specimens of the Family Group break away from traditional forms and each of them is a continuation, not the crystallisation of a proposition. Thus each organism appears to be able to expand and change in a crescendo of theories of cognition. One of the most interesting projects of 1944 is the drawing in the collection of Miss Jill Craigie in London, with the figure of the father showing a tunnelled hollow. Another idea can be seen in a group realised in 1945, the shelter model Moore was to choose for the bronze cast for the Barclay school in Stevenage.

Financial difficulties had prevented him from carrying out the Impington sculpture. In 1947 Moore received another commission for a Family Group for this other school, built with a view to present-day needs and with as great a didactic significance as Impington. The bronze shows a great iconological discovery, almost an epiphany in the Joycean sense, of form. The figures contain a human quality of great sonority and wider significance. It 'reaches and realises a unity between the individual-personal element and the supra-personal universal'. The series of Family Groups, then, does not only form 'a superb chain of happy human beings'. Its various planes which excite other relationships between arms and laps show plastic divisions which seem to express new ethical and social attitudes to the family in society and its essential reality.

25 *Double Oval*
1966, bronze
New York

37

The influence of matter

This is the moment to remember that the directions manifested in the Family Groups coincide with the sculptor's new work with materials of more general application, namely plaster and wax. The internal and external view from which the family is articulated answers the demands of the spiritual dynamic that Moore always followed. A detailed study of the *Family Group* in Stevenage shows a clear anticipation of the Internal and External Forms of some years later. But these were also a result of his experiments with the Reclining Figure and the Helmet Head. The symbolic, organic structure of sculptural layers flowing one inside another in a long sequence is already typified in the embrace that joins the Family Group. The relationship is symptomatic and is clearly seen in this 'naturalistic' sculpture; it propounds its connection with biological forms such as the embryo and birth. The family seen as a living receptacle.

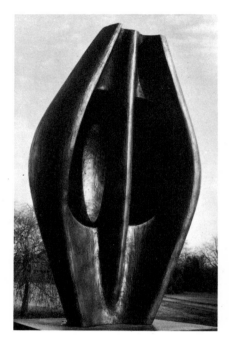

26 *Large Totem Head*
1968, bronze (8 casts)

Considering this other relationship, even faithfulness to material had lost its constancy and is no longer the main guiding principle. The original attachment to stone, which was strongest at the time when his eye was turned towards the primitive, now gives way to a more careful choice of materials which will express the flexibility he now wants. Moore made very precise comments on his new discovery in carving when he talked ironically about the sculptor who keeps several blocks of stone in his studio and goes around looking for one which incarnates or suggests ideas. It is a critical answer to the notion of the chance find, to the repetitive gestures which imply, in his view, the abandonment of the sculptor to the resources perceived in his materials. If anything, the sculptor has to let the figure that he perceives already in a piece of stone emerge from it. While respecting his material he 'must dominate it and not be at its mercy'. Working in plaster and wax for bronze casting enabled him to do things that he would never have done in stone. 'Bronze had an immense pensile force. You may make long, thin figures, wider at the top than the bottom, giving them elevation, a sense of movement.' And this discovery clarified some of his fundamental attitudes to three-dimensionality in matter-form, his obsession with growth, in the sense of organic growth 'created by pressure from within'. This tension animates any thing or form in nature in its internal being.

When Moore looks at things, it is not their external attributes that he sees. He talks about, sees and feels their vital concreteness, as a biologist-poet might interpret them. He talks about 'the growth of a flower', about the energetic, solid fleshiness of a beech trunk. Everything can be a lesson to the sculptor, 'like a pretty girl or a young girl's figure'. They are all parts of the experience of form and that is why, in my opinion, everything, every shape, every fragment of natural form, animals, people, pebbles, shells, anything you like, are things that can help create a sculpture. But every form shares in that vast concept of matter in which the form is embodied. And form has to be felt as a vital force exuding from within rather than a shape which is seen from the outside and no more. Even those elements we called key points in a living form – such as knee, shoulder, skull and forehead in the human body – are elements of a force, or pressure, which animates the mass and gives it its quality, and redisposes its variants and narrative surprises.

This is the frame of ideas within which he worked on his next sculpture, the great Reclining Figure. The swelling of its drapery alternating with hollows makes us feel its form and inner space. Moore's sculptures become more and more part of the earth, they assume the grave, impenetrable calm of landscape. His preference for hard, heavy materials, and for carving that marks but does not model, coincides exactly with his vision of, and participation in, the life of matter and the world. Plaster received the same full treatment; it is hard stuff – 'I file it and cut it'. And this produces endless stratification, till it resembles the great age of Earth in the huge stretched-out figures of 1962 and 1963 like the ruins of some ancient catastrophe in a geological regeneration.

From 1945 onwards Moore worked on the reclining figure motif again.

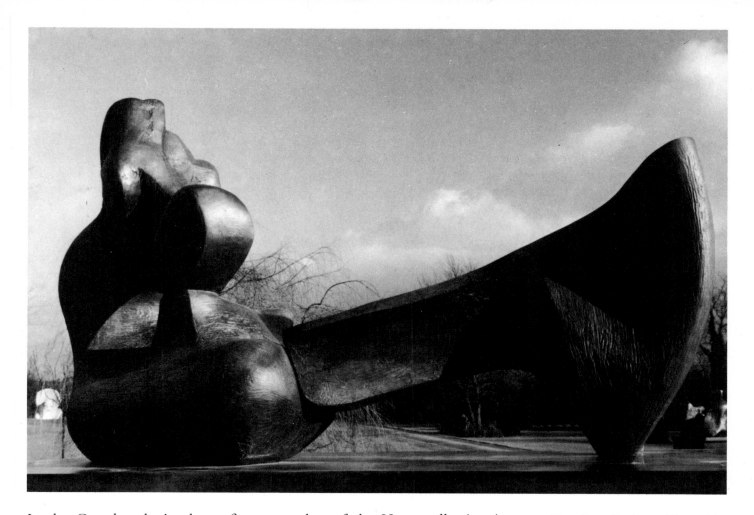

27 *Two Piece Reclining Figure No. 9*
1968, bronze (7 casts)

In the Cransbrook Academy figure, or that of the Hope collection in Bloomington, there are vast recessions and twisted protuberances. His carving in elmwood gets involved in knotty branches, or stretches out in ample resurgences and cavernous depths. The sketch-model on which he based the Reclining Figure of the Sturgis Ingersoll collection in Philadelphia is also freely penetrated with hollows. Moore's work during this period shows acute mental as well as technical tension. Various forms are born either from progressive paring away of the material or from the piling up of masses. The hulk of the *Reclining Figure* at Dartington, and the *Three Figures* in Battersea Park, even the windy hollows of other Reclining Figures, are distinct aspects of the same problem. The full mass concentrates and emphasises the human element in a calmer, smoother finish of surfaces.

In the Reclining Figures where Moore has acted with total liberty, space is mirrored in the holes and in the full mass of the body. The ever-increasing similarity between his figures and natural landscape goes hand in hand with his own desire to see his work in the open air. Its place is out there where one may come across his sculpture as one might come across some rock; one may walk around and appreciate it from every angle. He did not like the placing of his *Family Group* against a baffle wall in the school at Stevenage. The screen wall served to hide an ugly joint in the building but stopped one from walking all round the sculpture. This idea recurs frequently in his statements and implies his view of sculpture as a continuous rhythm, with unlimited points of observation. He works with greater freedom on the matter-form when he knows that it is going to be set in open space, to be seen fully.

The memorial figure in honour of Christopher Martin, the first Arts Administrator at Dartington Hall in Devon, acts as its function demands, as an illustration, similar to that expressed in his Gothic Revival Madonna in St Matthew's. Its masses are energetically disposed, but that does not prevent, rather it increases within the viewer, the disturbing sense of the powerful extension of space all round it.

Fig. 10

A boundless creative freedom

This is also the period of the sketch-model for the *Three Standing Figures* in Battersea Park, carved in stone in 1947–48. The 'Three Ladies of Battersea', as they are popularly known, provoked an extraordinary reaction when they first appeared. This was due to the acutely metaphysical synthesis that the sculptural technique contains. A strange peculiarity of slow ripples gives the three ladies a ghostly life. They inform us, show us something, revealing a calm state of mind. In reality they are 'no more than the germ, grown to disproportionate size after long incubation in the womb of the earth, of the *Three Furies* of 1941 and 1942. The calm architecture of the group emphasises the mystery of the three being scrutinising the distance from the holes which are their periscopes' (Zamboni).

There is also, from 1949, the series of Seated Figures which, from the drawings to the actual bronzes, depicts a thinning of the image till it becomes almost a moving shadow in space (as in Giacometti). But Moore's work recalls the myhthical figures of native figurines. A greater mastery of carving enables him to narrow and refine the figures till they are arched, 'open and slender', to a degree that wax makes especially possible. It may be that the interest in so every-day an idea derived from some scene at home after the birth of his daughter Mary in 1946. But soon afterwards, in 1950–51, there is an increasing number of contour lines in his drawings which penetrate to the core of the life of forms. From these there emerge heads and caged figures, as in the drawing in the Heritage collection in Los Angeles. This was an advance warning of the advent of the enigmatic double form of the Helmet Head, whose shape sometimes has archeological and heraldic over-tones, but which displays above all the exquisite, disconcerting mastery of carving which led to new forms and new births: shells in the shape of helmets with mysterious cracks in them. One paper has drawings of a woman in armour. In 1954 the series of Helmet Heads appears among the richest of his fantasies with hallucinatory variants. These same forms fascinated Chadwick, Armitage, Roszak and Minguzzi.

The fabulous animals or human shapes with extensive markings which appeared in the Mural Painting of the Experimental Museum in Mexico City suggest some paleontological drama, of human and geological evolution. The visual connection with origins revealed by anthropology is so marked even in the *Helmet Head* that the *Standing Figure* of 1950, standing up on stilts, is no more than an extension of ossified conglomerations, of the 'souls' incorporated in the *Helmet Head*. This latter sculpture makes one think of the specimens from the Cyclades, and even more of some figures by Picasso (lithographs of 1929). The two figures of the *Double Standing Figures* also seem like mechanical giraffes and might be understood as an allegory of Moore's experimentation, his longing for a reappraisal of the symbiosis of the human figure and space. This coexistence is difficult because each of the two figures tends to grow and predominate over the other: space crushes the figure and wants to enter into it while the human figure rejects space, wants to expand and fill it out, to become part of it itself' (Bucarelli).

Pl. 13

From tressel figures, via leaf-like figures (such as those in Jesus College in Cambridge, and the Prado, Madrid) in 1952, to the shell figures, shows a tireless progression of the senses and imagination towards the stages of new-created philogenesis. In the *Reclining Figure* of 1951 the development of forms and spaces is in equal relation. 'In my latest bronze, the *Reclining Figure* (he said in 1954), I think I have succeeded to some degree in fulfilling my aim', that is to say, in achieving a perfect balance between the hollows and solid matter. In the Arts Council *Reclining Figure* the viewer under-stands the whole unfolding of the figure if he looks along its length from the side of its head, and notes all its hollows between which the limbs are wedged. 'Forms dwelling in a tunnel in recession.' The sculpture is like the skeleton of a huge fossil from the ice age. The way he has worked out separate aspects of structural laws results in an impressive display of their relative possibilities.

Pls. 14, 15

Moore was free to think of his materials without worrying about their ultimate site. This was a time of unlimited creative freedom in which we discover not only the perfected growth of those knotted bodies, but also the viscous, smooth form of the *Draped Reclining Figure* for the Time-Life building in London, not to mention a study of Internal-External Forms and the screen for Time-Life.

Many other pieces prepared the way for the bronze extension of the Draped Reclining Figure of 1952–53. Here the drapery is treated objectively and not as 'landscaping'. The secret is pursued through the heavy sculptural weight of the garment which is wrapped round the raised knees and falls away into their hollows. Here the light plays as on folds of rock. The *Reclining Figure* was meant to be places on the terrace of the building and thus was entirely independent of any control exerted by the architecture. With the other work executed for Time-Life, a balustrade, Moore had to deal for the first time with something that was to form part of the structure. However even the terminal screen of the terrace with the energetic asymmetry of its geometrical perforations adamantly refuses to be dismissed as merely a decorative addition to the architecture. It is an insert, but not a decoration. These works have some archaic feeling and are built up into a meaningful construction, vitalising a space which is not bound to the building by form or significance. Moore made the balustrade a visual interruption, creating this sense by the depth of incision of the detached pieces, each one isolated from the next and with carving on both fronts. This allowed the light to play over every part of the sculpture and thus altered the visual feel of the whole building. From Bond Street, from which one can see the effect of this screen, one was to enjoy the whole of its rhythmical richness and organic gravity. At any rate, even in his plans for the integrated whole, he never wanted to build a stone poster, nor a bas-relief illustration.

The first maquette showed regular rectangular niches, but he rejected it on the ground that 'it was, perhaps, too regular and obvious a repetition of the fenestration of the building'. In later ones he suggested a greater variety of rhythms. In the third, rhythmic verticals alternated with organic and geometrical ones, but resulted in a monotony which the sculptor disliked. The final version made greater connection between its parts. Other ideas came up while he was executing it, such as the subdivision of the whole sculptural complex into four distinct components, each worked on every side. Moore wanted to round them off even more to make the continuity of the relief and internal structural energy clearer still, but the blocks were too massive and heavy.

1952 was the year of one of Moore's most famous sculptures, *King and Queen*. It is the final work of all the ancient royal monuments and *stele*, but seen from contemporary viewpoint. His journey to Greece (in 1951) and his remembrance of other ancient civilisations (Egyptian and Sumerian) had already become noted in his mind as interpretations of myth which can connect 'the present to its origins in the most natural manner'. The statue exudes a strange melancholy as if its most genuine symbol was grandiose solitude. Thus the group can be seen in its logical setting, an outcrop of rock near Shawhead, Dumfries in Scotland. The image contains that intense 'Vital charge' that makes Moore's work 'coexist and merge with human destiny' (Grohmann). In the grave solemnity of the two solitary beings, there is an almost totemic atmosphere. Moore's scale is that of an Olympian world undisturbed by its sidelong glance at the affairs of man. Herein lies its regal and hieratic, almost fairytale, qualities, uprooted from reality and sunk in an abandoned torpor.

Kenneth Armitage increased the feeling that can be noted here, too, in the *Angst* of his sculptures, pared away as they are till they become flat slabs, as though time had roughly planed everything to one single scale of matter. Moore spoke of his work as the result of abstraction and a certain

Fig. 12

Fig. 13

King and Queen

Pls. 16, 17

amount of realism. 'Perhaps the key to the group is the king's head, implying a shape that is at once head and crown, face and beard, that makes one almost think of Pan because it is animal-like and yet at least, as I believe, regal.' A mixture of the grotesque and the solemn: a myth reviewed in the light of the critical and ethical unfolding of history.

In 1953 there were some more examples of the Mother and Child theme, produced with aggressive thrusts like works by Picasso or Zadkine. The knotty material is articulated in multiple variants of plastic expression which are converted from plaster casts into bronze with the same incisive, continuous emaciation. To the casting of the various parts of the *Draped Reclining Figure* for the Time-Life building we directly owe the surprising, beautiful *Draped Torso*, a superb fragment corroded by time.

Fig. 15 From here it is not far to the *Warrior with Shield* of 1953–54, where the conflict of forms is emphasised. The cleft which comes right down the middle of the skull expresses 'a certain resignation, but disdain as well. From the contrast of the head with the natural structure of the rest of the body, the idea of the figure as a whole stands out the more'. The figure's twist is also emphasised by the narrow, separated knees and the bony arm carrying the shield; this is thrust forward while the other is cut off at the shoulder, a stump. It is the whole figure that fights with space by making it multiple and circling it in every direction. It is a kind of motionless kineticism, expressed in sudden advances and retreats. In 1956, the *Falling*

Pls. 24, 25 *Warrior*, a figure crushed to the ground, is a form of 'a dumb, animal acceptance and forbearance of pain' (James). Images like this may be evoked by some quality in Greek sculpture (since Moore mentions it himself) but the role played by the figure's truncations is not the same as that of fragments or idealising arabesques.

Pl. 18 Contemporary with these is the *Internal and External Forms* which he had worked on constantly throughout 1951 till 1954. This work, which recalls Arp's *Ptolemy* of 1953, has typical, key characteristics which explain fundamental features of Moore's work. Moore made one model for it in 1951, 7 inches high. Then a working model in 1952 in plaster about six feet tall, then one in elm wood, now in the Albright Knox Art Gallery, Buffalo, New York. The experiment with a unitary organism of form-in-space which here takes on a collected shape, axiomatic and valid in itself, had been pre-figured in the large pieces of the Family Groups and Reclining Figures. It is the mysterious example of an internal growth, a growth from the inside which unfolds into open space even if it seems limited, enclosed within the curves of the sculptured capsule. Wood, a natural, living material, is ideally suited to render internal and external forms which may include the archetypal principle of Mother and Child.

This kind of development of embryology was also achieved in the Reclining Figures which now become vast, shell shaped; from the 1953–54 models Moore was to cast various pieces in 1957.

Fig. 17 In the sculpture *Head: Lines* of 1955 the vibrant from moves, both topographically and biologically. The lines in relief are nerves which energise the mass. The indications of construction that had been only external in 1937–39 now become strictly inherent and enable the body to rise and live. In the same manner as *Head: Lines* Moore also composed the *Wall-Relief: Three Forms* of 1955. This was a preparatory work for the exceptional example of integrated sculpture which he was working on for the Bouw-centrum façade in Rotterdam. Commissioned in 1954 after a series of carefully worked maquettes, Moore worked directly on the wall 'as if it were a monolith' (Trier). The entire façade becomes the sculptor's material. On it he marks only breathing movements in which the internal space seems to rise up and burst out through the anonymous mass. The broken-up surfaces of brick itself (which was a new material for the sculptor) point out that the occasional swellings on the wall are of the same material (intangible, actual and mysterious) that curls up and moves along the surface like a continuous yet profound disturbance of the uniform body of the

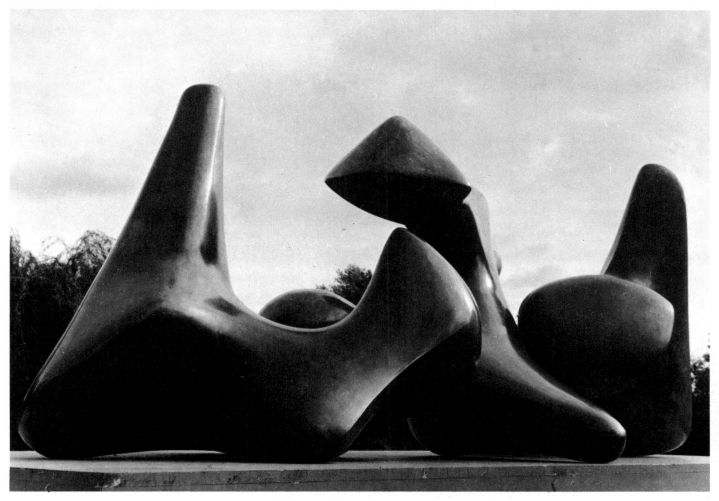

28 *Three Piece Sculpture No. 3*
1968, bronze (8 casts)

façade. Thus the sculpture is in no way subservient to the architecture. It is absolutely devoid of pictorial quality; in fact it has no precedents in 'integrated' works unless we go back to very ancient specimens (Grohmann recalls Sumerian constructions, especially the snakes carved on the temple of Innina di Karah-indasch at Uruk). Its relation with Hans Arp's relief on the wall of the Graduate Centre of Harvard University in Cambridge, Massachusetts (1950), shows a likeness in the material (there it is wood) used by the two sculptors in both the scultural components and the wall. But in Arp's bas-relief the forms are ideographs, rhythmical cuts into bodies of extreme linear refinement. They stand separate like optical marks modulated by a masterly command of space.

Object sculptures in the countryside

Between 1955 and 1956 Moore produced those amazing totem-like sculptures he called upright motifs, among them the Glenkiln Cross, which stand up like the wasted relics of men or trees. Memories of medieval Anglo-Saxon crosses, tribal art motifs ('North-west American totem poles') and the vertical rhythm of a tree itself ('a Lombardy poplar', Trier) led him to these puzzling landmarks.

Pl. 21

But Moore makes all his works his own. In 1956 he modelled another *Upright Figure* (1956–60) for the Guggenheim Museum, New York. Worked with patient, incisive carving, it is hollowed out of the thickness of an elm trunk. From this it burgeons like an enormous torso, with powerful legs like columns, its feet still fastened in the material which is itself its form. The material embodies its own evolution, has its own life in which, mysteriously and laboriously, organisms are reborn.

Among the most imposing works of the last fifteen years is the *Reclining Figure* for the UNESCO Building in Paris. Executed in 1956–57 it is significant for the whole series of figures that led up to its final composition and siting: motifs and figures placed against a background. The problem lay in isolating the figure from the fenestration of the building behind,

which would have prevented a complete view of the masses and their space. Moore studied this 'very harassing problem' in a great number of maquettes, trying various types of background such as flat, curved, perforated, that would allow an independent visual appraisal of his sculpture.

These variations were later neglected when he came to the *Reclining Figure* in travertine, isolated by its own potent character like a kind of perforated mountain. It rises up like a symbol of unity, quite able to impose itself at a distance because it contrasts so sharply with the architectural backdrop, and its shape is existential, like the back of a chain of hills. Rock, bone and the crude energy of the material have become the matrices of the sculptures of his latest period. Certain organic and inorganic typologies seem to go through an endless series of variations becoming almost the results (always on a monumental scale) of narrative methods. But after the great *Reclining Figure* for Munich, with its frenzied drapery, there appears, from *Relief No. 1* onwards, a monstrous increase in the size of the mass. The erosions of the *Two Pieces* of 1960 are already at work so that the figure becomes embedded in the mass and survives only in the amorphous grandeur of the whole. It is the revelation of an 'other world' that surrounds every figure, every thing. Its animation comes not so much from the figurative element, which is still seen in the one-armed torsos and protruding forms (the 'heads'), as from the concretion of matter which becomes charged with a feeling, a power of erection, as if it were self-activated in its massive, impenetrable nature. Here Moore recalled the subdivision into pieces of his *Reclining Figure* of 1934. Even at that time the 'abstract' vivisection was a means of aknowledging space. With these later rocks he talked of a transitional stage after *Internal-External Forms*. The huge figures in two and three pieces show his additional interest in particular natural forms (the Adl Rock, near Leeds, Yorkshire) and in the Rock at Etretat, painted by Seurat in 1885 (Tate Gallery, London). Moore certainly accomplished this gigantic development not only through a fundamental study of natural forms in reality and in nature, but through his concept of plastic creativity which continuously developed the same themes. It is precisely this obsessiveness that leads him to know and reveal limitless views of the forms that exist inside and outside his imagination.

Despite their separation into two or three blocks these sculptures remain 'interdependent . . . to such a degree that they cannot be separated' (Read). What has taken place is a realisation of the object sculptures in landscape that had appeared as ghostly visions in drawings of about 1940, in which strange, bundled objects indicated a metaphysical scene. This in turn had been conceived as an image of contemplation, at a distance therefore, and in a frame. The great bone and rock bronzes of 1960 onwards have surfaced in anthropological space, growing in the earth, physically blocking the surroundings like formations in some fresh geological apocalypse. Their meaning is not pacific. This gives a concrete presence to the dark forces of the world and of human destiny, against which man struggles in vain. But this is not merely a regression to the potent forms of Stonehenge; it is, rather, a condensed sensation of obscure events. The rampant monsters of Surrealistic painting (Magritte, Baj) seem like visual euphemisms, a subtle, fantastic extolment compared with these warming meteorites that weigh down upon urban ground. The bone figures give 'the impression that they demand obedience' (Marchiori).

Pls. 36, 37, 43, Fig. 25 There is in these late works an astonishing variety of forms: organic emphasis in the *Seated Woman* of 1961, an elaborately worked bronze of woman, shell-shaped; the impressive series of great articulated pieces from *Locking Piece* to *Atom Piece* 1963–64; the inestimable *Double Oval* of 1966; *Two Piece Sculpture No. 7* to 1966; *Two Nuns* of 1968 (in reality shaped like white internal form of shells); *Pointed Torso,* of 1969, and other devices in extraordinary metaphors. Yet despite this variety Moore's mastery continually effects maximum liberty in the figure. He would like 'to lead form as far as possible without defining its meaning'. In 1962 he said that

he has composed two or three forms without knowing what they are. But anonymity does not mean that they are works of chance, even if one is aware of their approach to formlessness. His work style had already been guided for some time by a creative consciousness that increasingly clarified its aims. His artistic individuality, however great, is not diminished in the least even when form and choice, critical judgment and the value of each realisation, seem obscured.

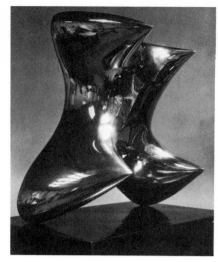

29 *Pointed Torso*
1969, bronze (12 casts)

Sculptures like the *Large Torso* of 1962–63, and the *Two Piece Reclining Figure No. 9* of 1968, seem to symbolise the scientific and sculptural experiments of the mid-century, those conducted both by Moore and his fellows (Arp, Duchamp, Villon, Archipenko, Picasso, Hartung). But they are embodied in results that seem invoked by a more dramatic, sterner effort to open sculpture, and artistic activity in general once more to valid expressiveness. Not only the statue but all forms of the created article are found within matter which is thoroughly worked out in 'continual, changing, never-ending surprise and interest'. Thus the spectator may enjoy, because it opens his eyes to knowledge of the world and art. Moore's success with the public is also due to the kind of constant visual attraction of his formal development which is discernible in even his most austere transmutations, the figures consumed to the bone. And sometimes faint echoes resound of distant visions, which are their mental rather than formal archetypes. Stonehenge and Mycenae return even in the rocks and caverns of 1960. The *Winged Victory of Samothrace* reappears in the *Knife Edge* of 1961.

From the active continuance of Moore's artistic experience many ways have been opened to successive generations of sculptors, both in Europe and America. Most probably, however, it is not this discovery or that figuration that has had the greatest influence, but his global concept of matter, form and space which at different times in his development has enabled him to contemplate and anticipate a great number of things. Yet Moore has maintained his faith in constructing methodically and by participation, and has attained spiritual energy just by the obligations of method. Perhaps there lies at the very root of his achievement the persistent effort to express 'Grandiose, elemental forces' as in Blake's dream. But Moore's grandiosity issues from, and is permeated by, the scientific discoveries of his time. Moore has reckoned with their impact, and via it continued his experiments with the inexhaustible primordial sources. His vision does not rise, therefore, like that of the Romantics, on vast biblical wings. They are instead witnesses to human history and science corroborated by an artistic method that seeks its own space afresh by activating other formal and imaginative values.

In 1962 Moore remarked how the dispersion and plurality of artistic experience levelled every choice and every experience. As for his sculpture, what confirms the reality and truth of its assumption is its willingness to be a cognitive, creative art in which the innermost impulses are elucidated as well as its deep concern with the problems of life and contemporary human society.

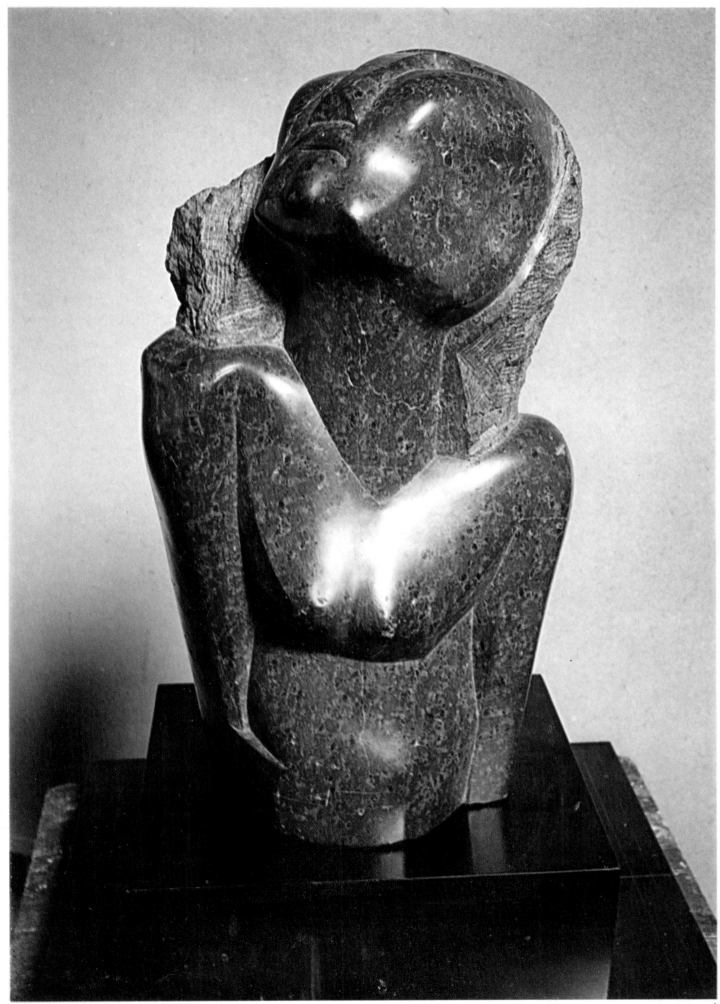

1

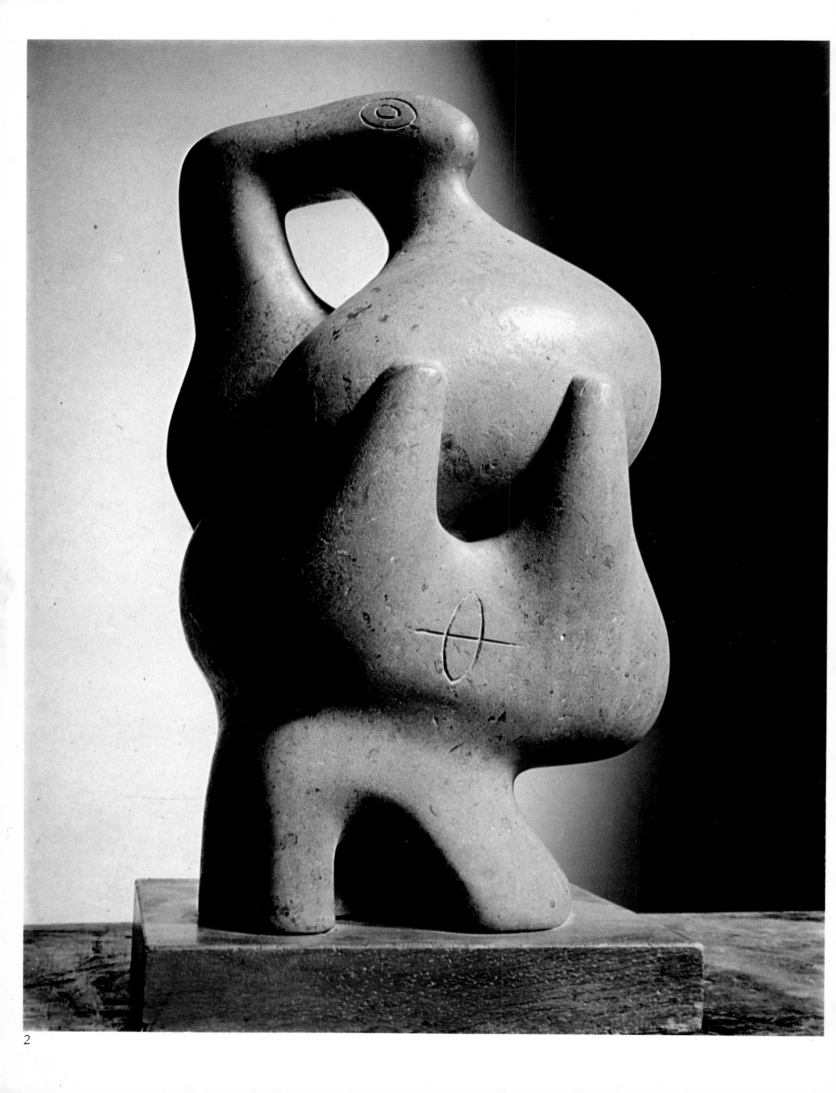

2

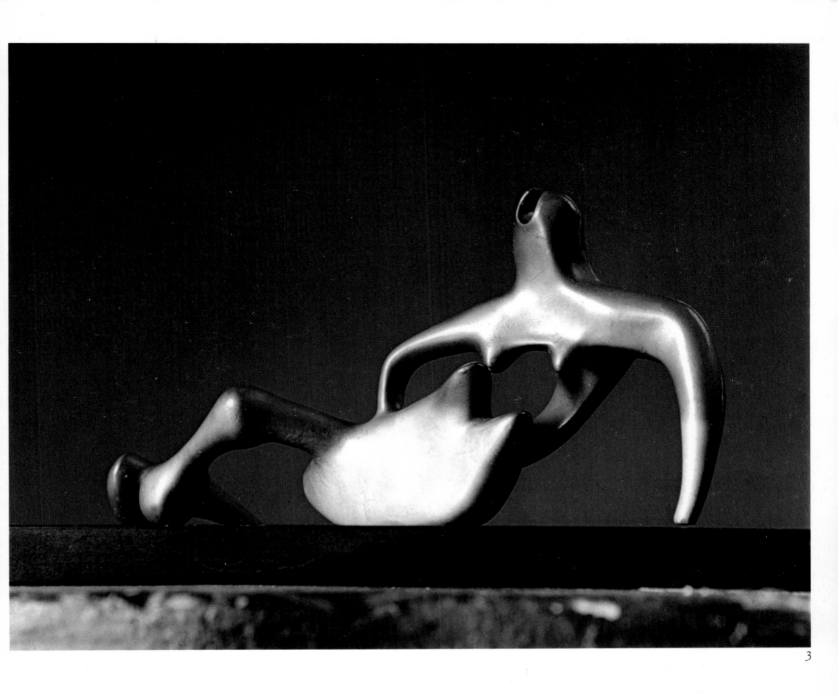

3

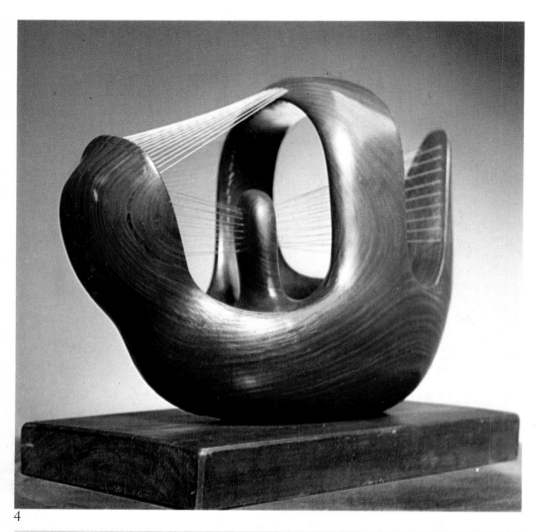

4

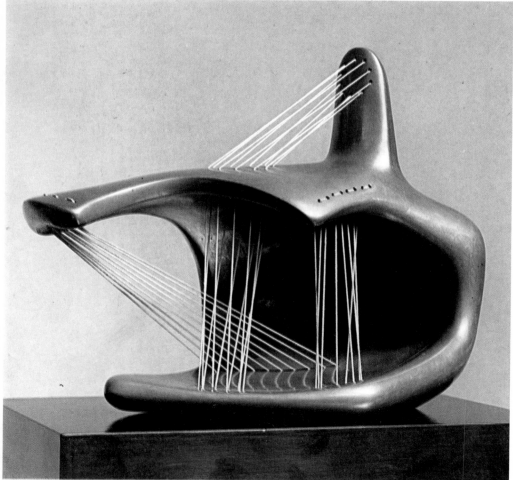

5

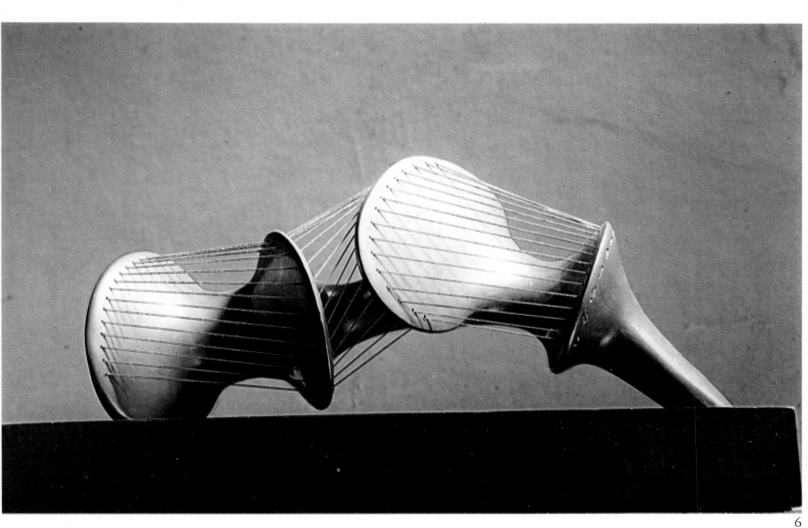

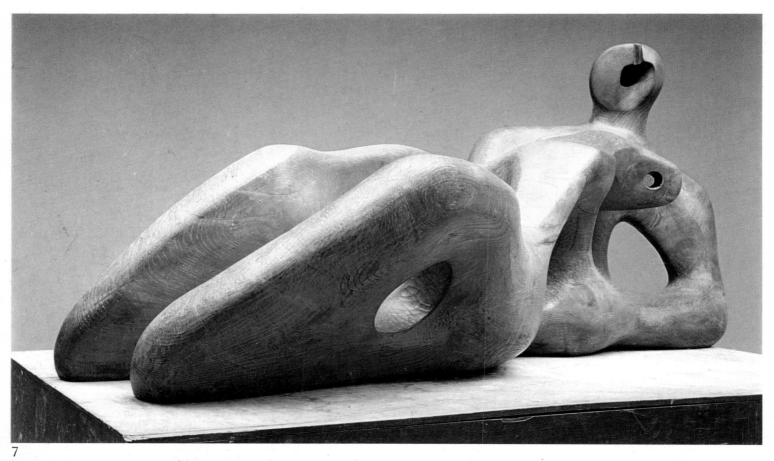

7

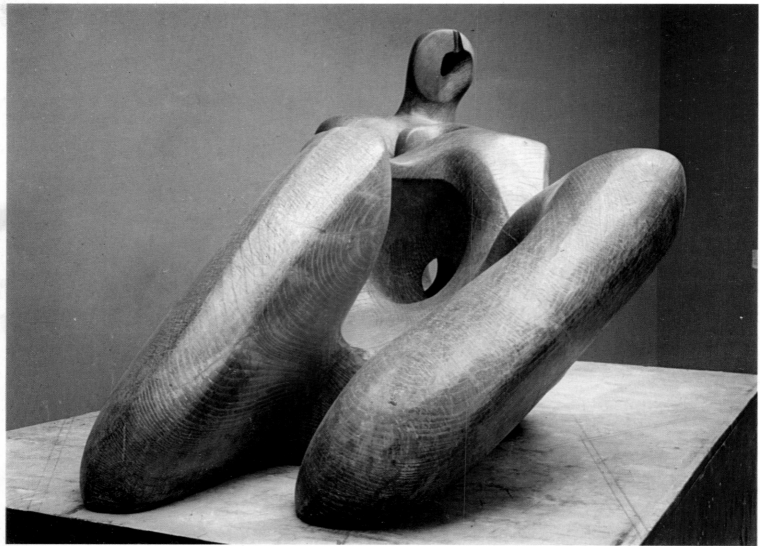

8

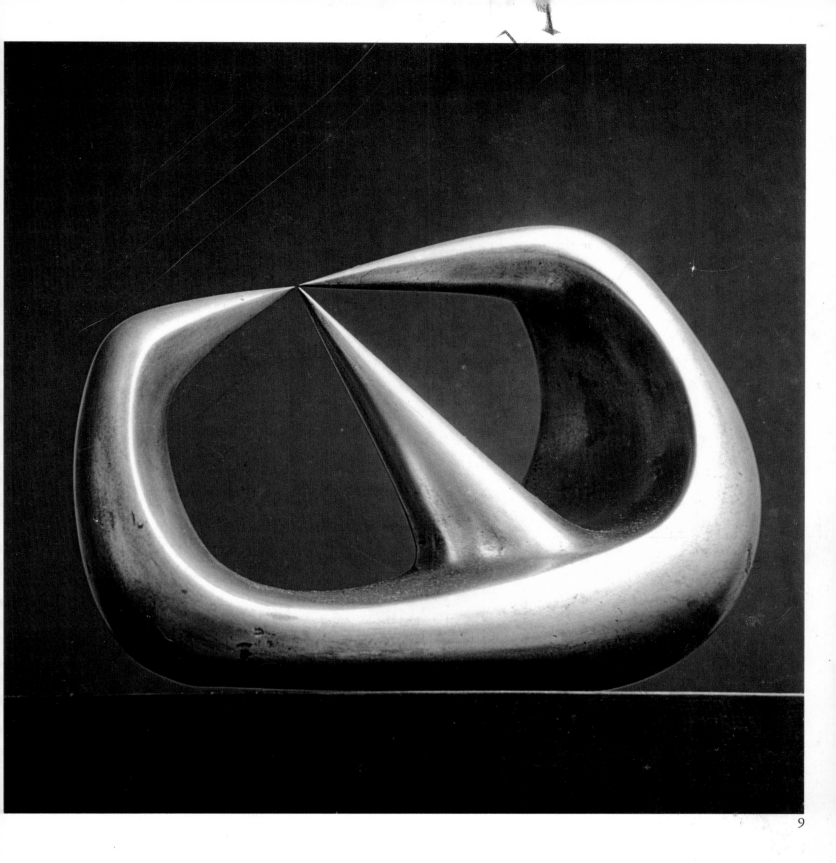

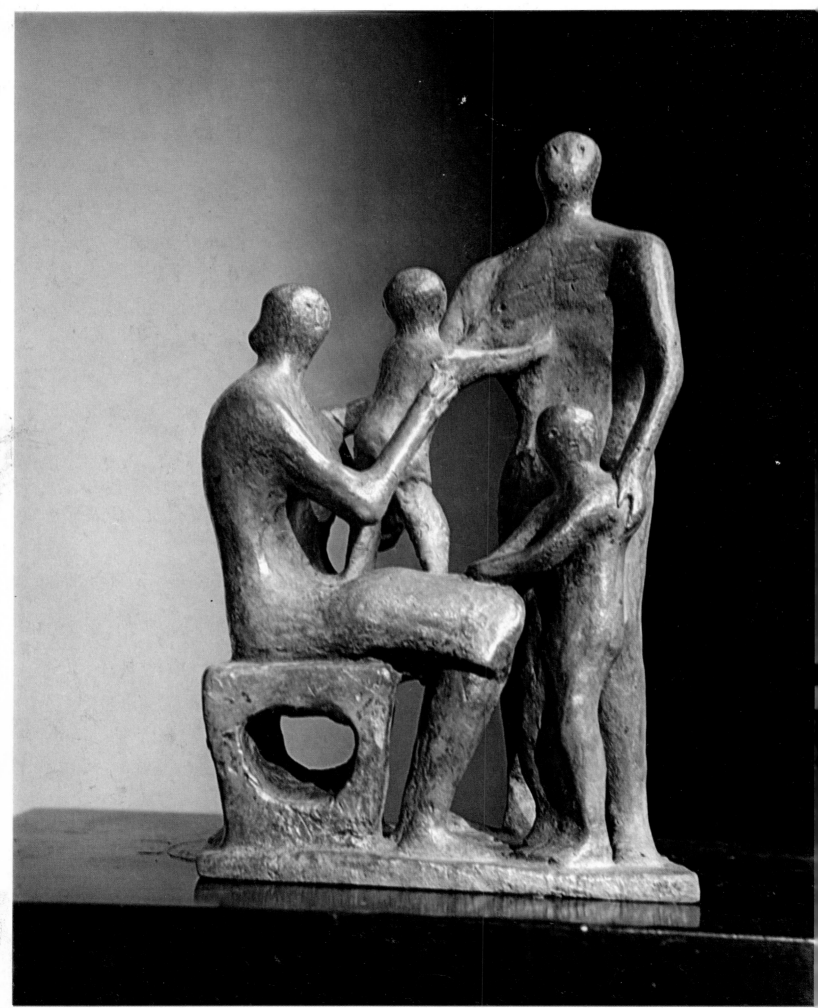

10

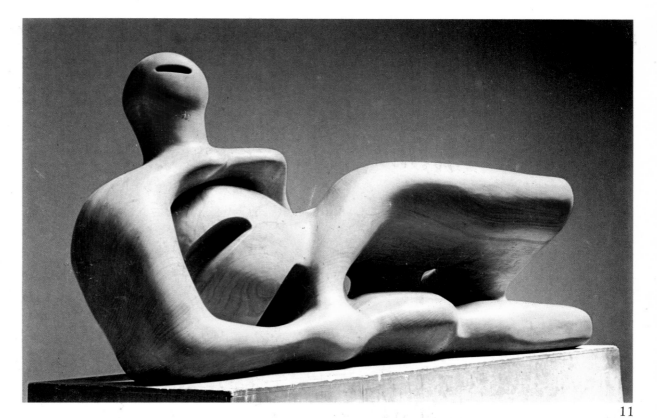

11

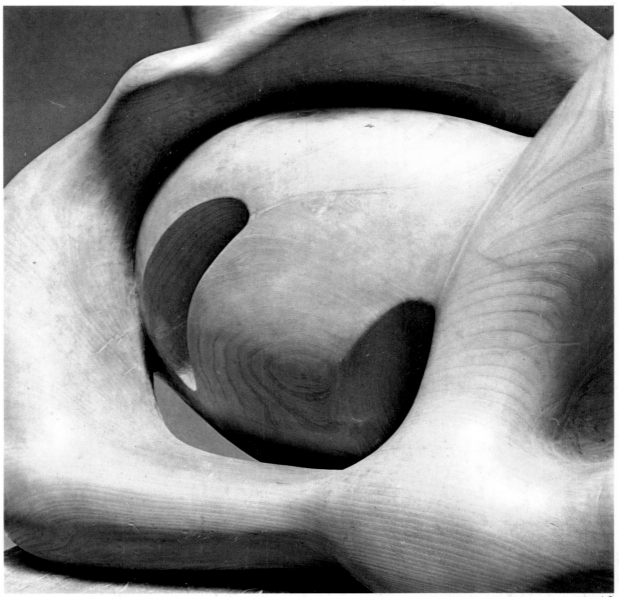

12

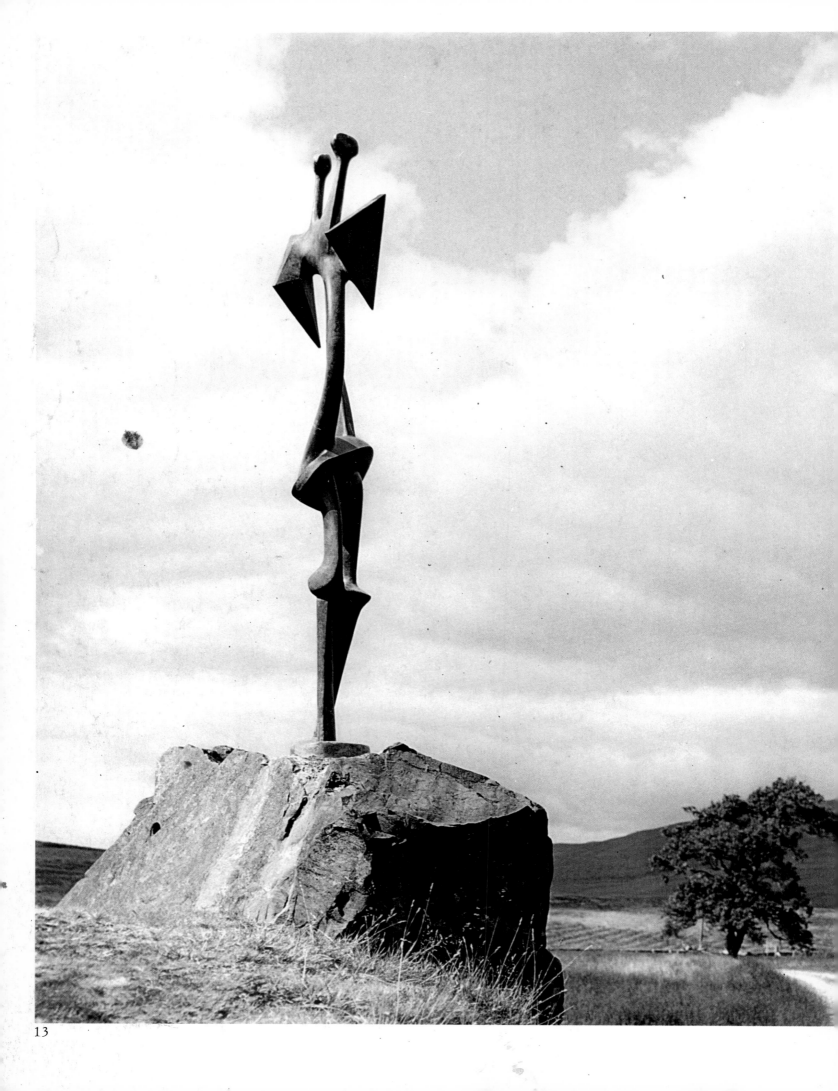

13

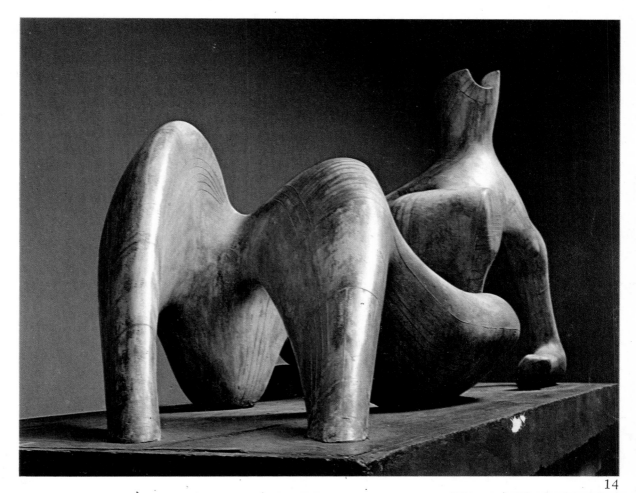

14

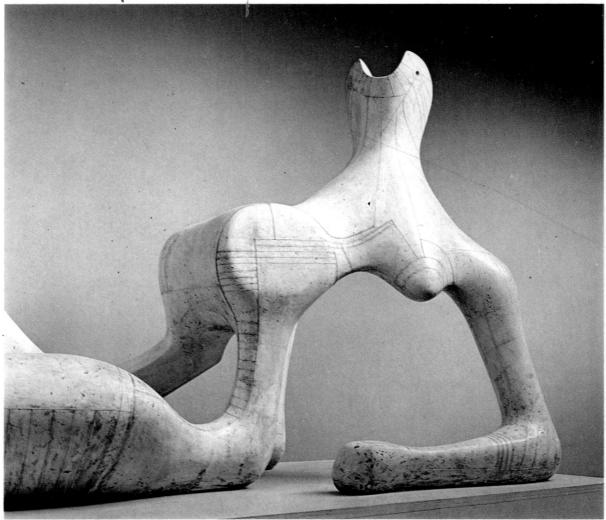

15

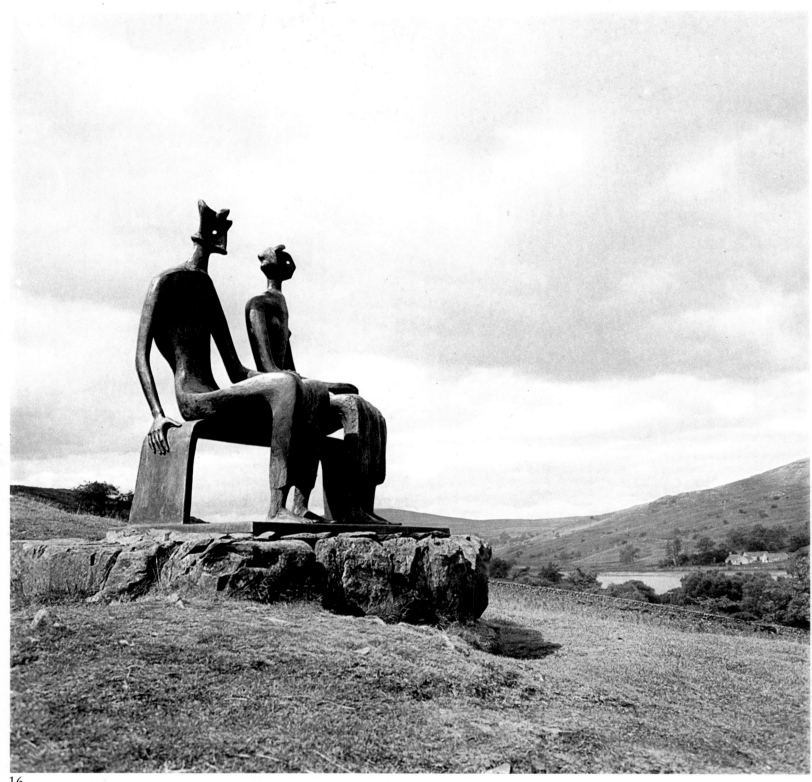

16

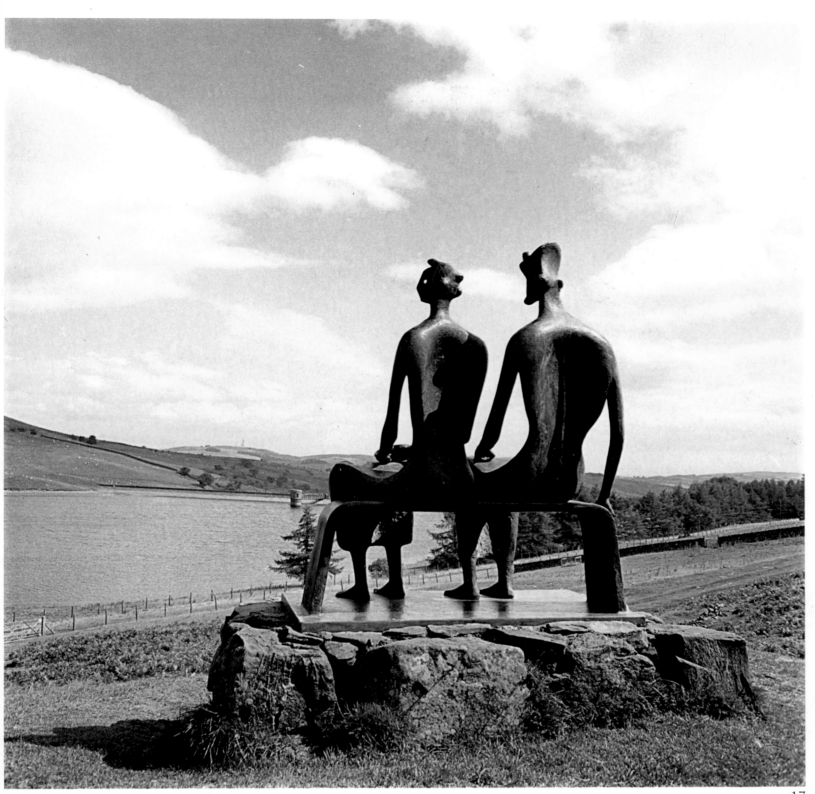

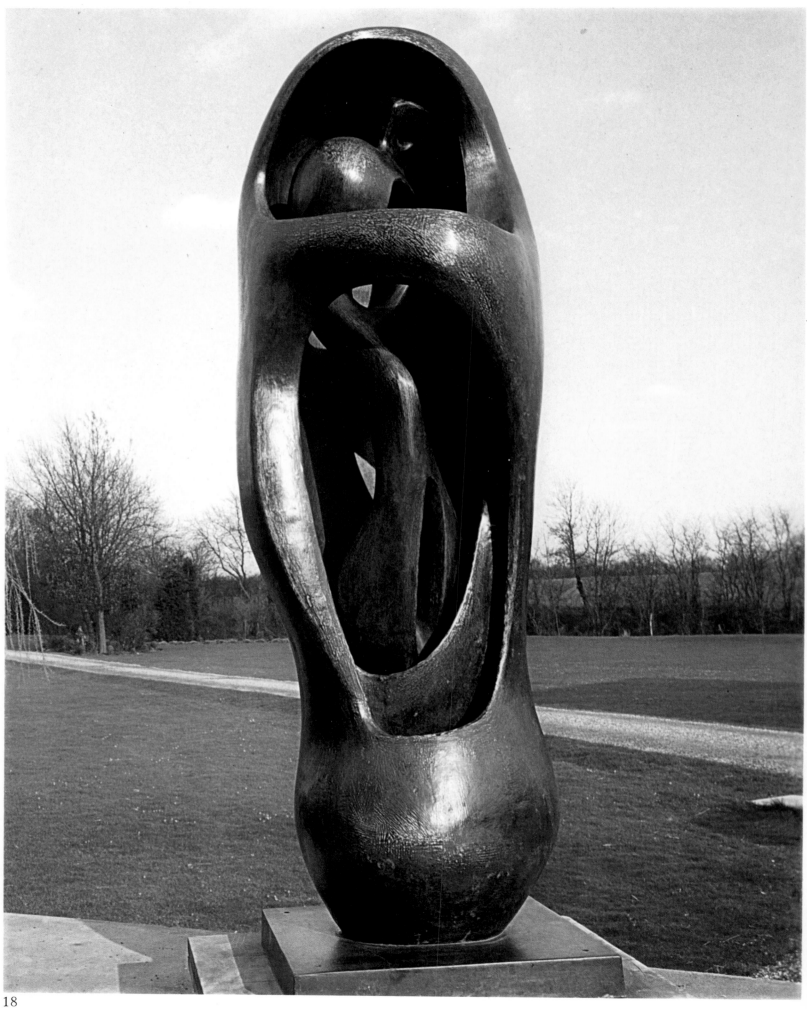

18

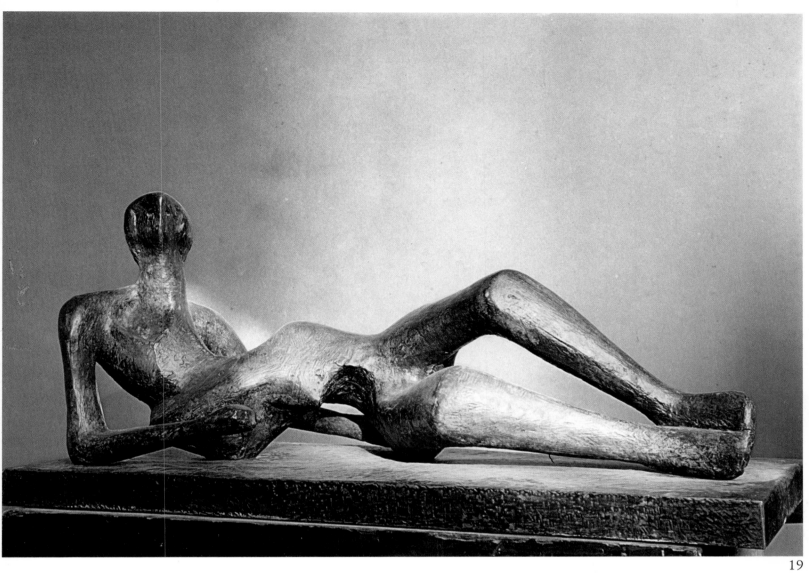

19

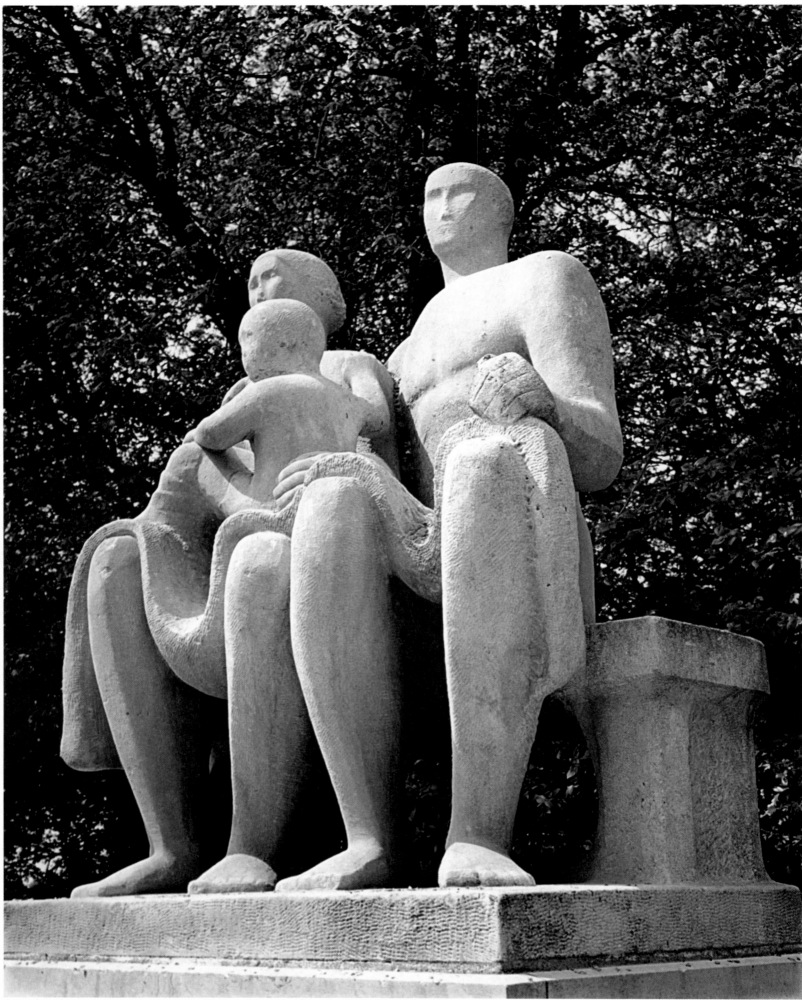

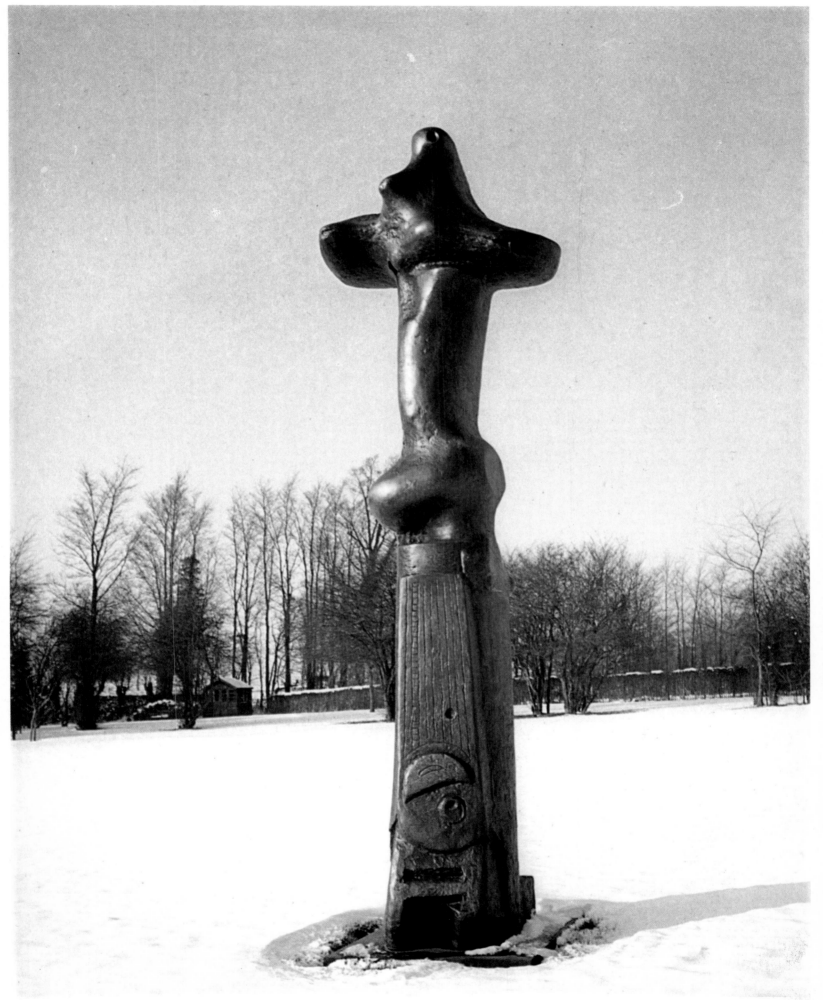

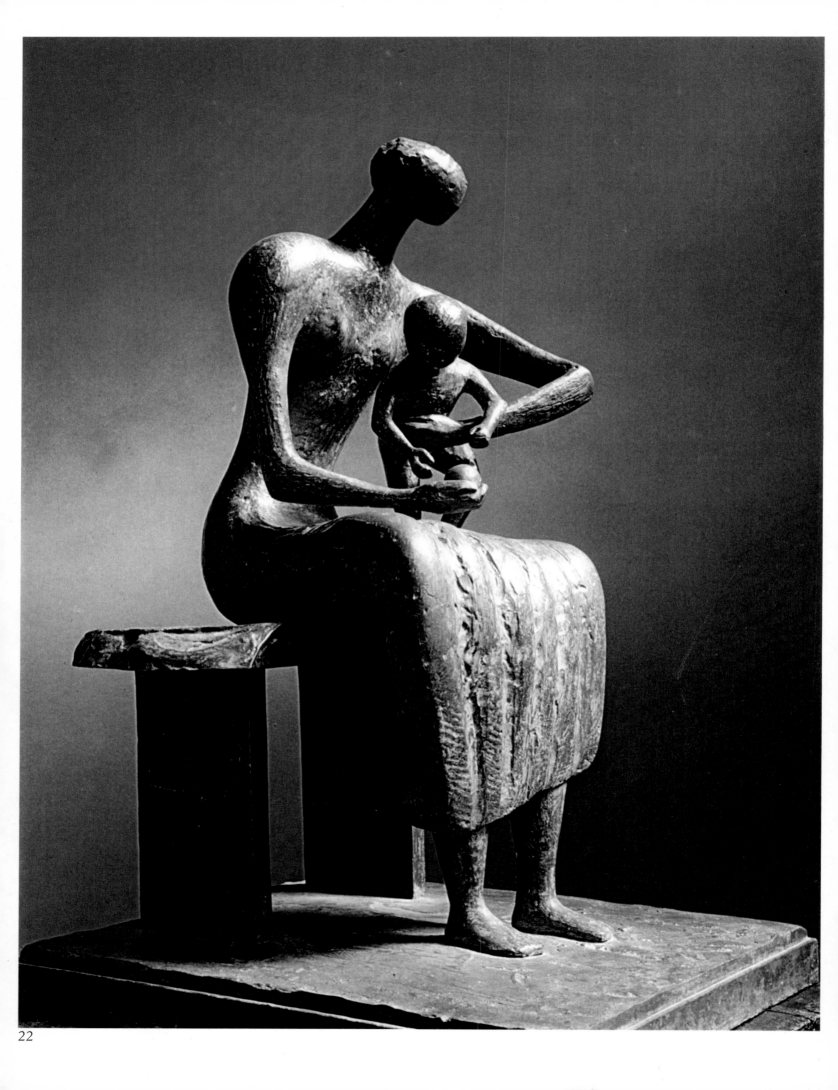

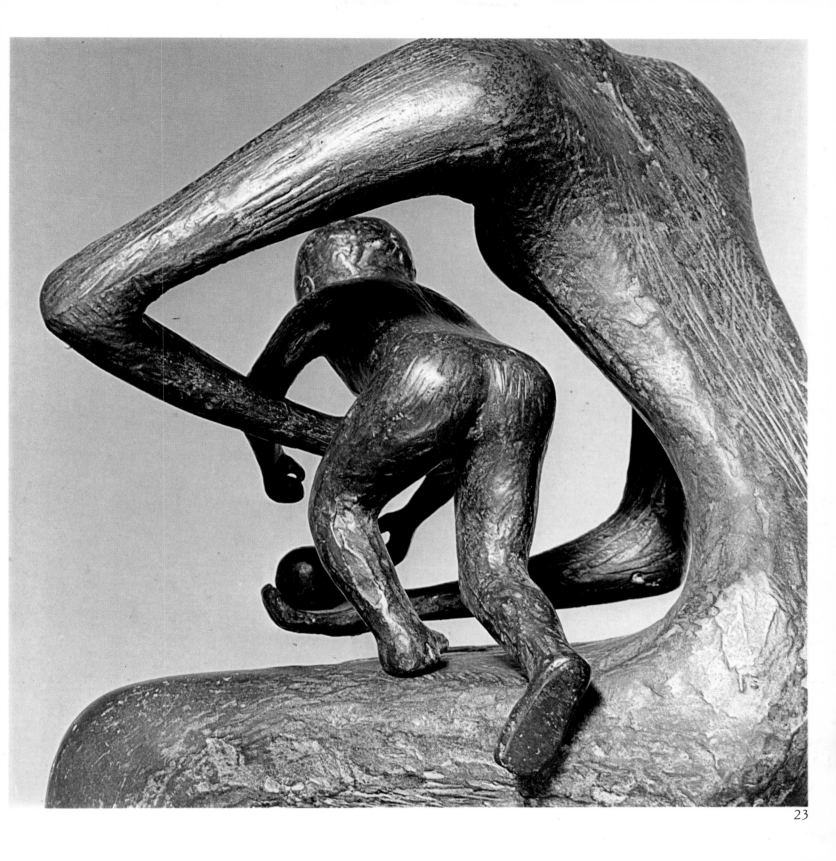

23

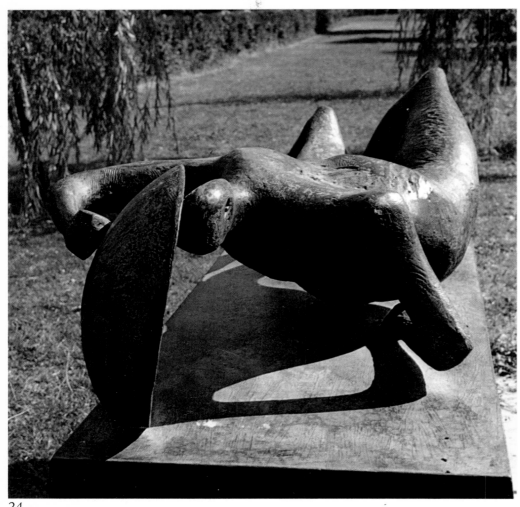

24

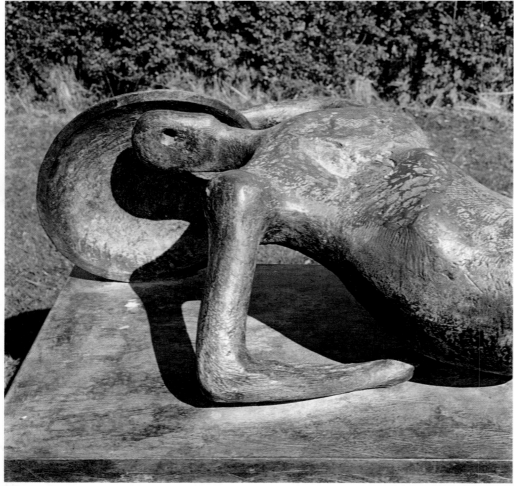

25

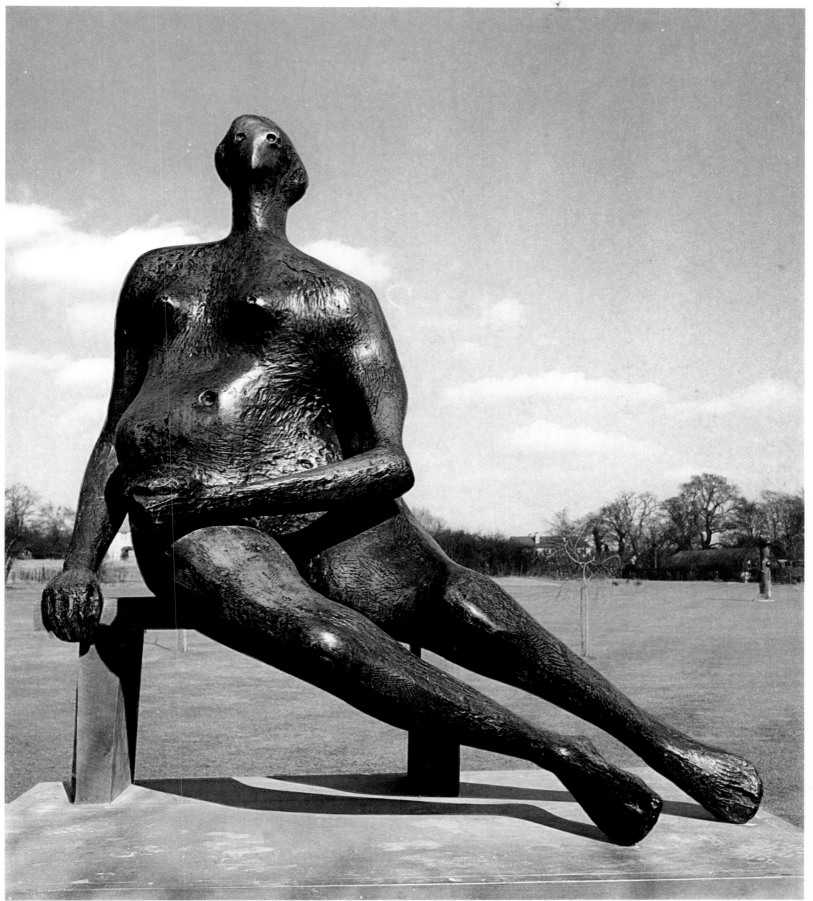

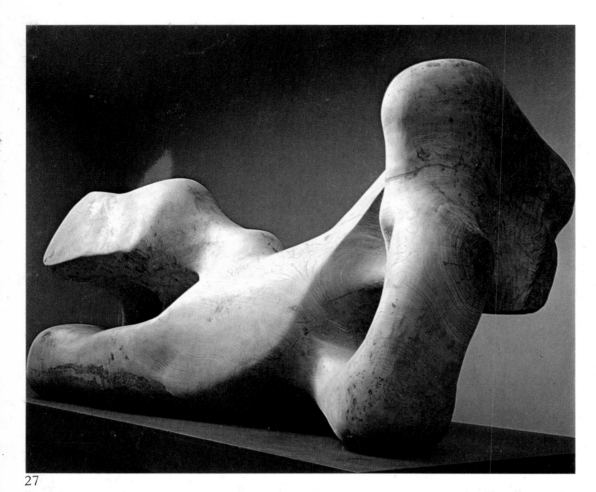

27

28

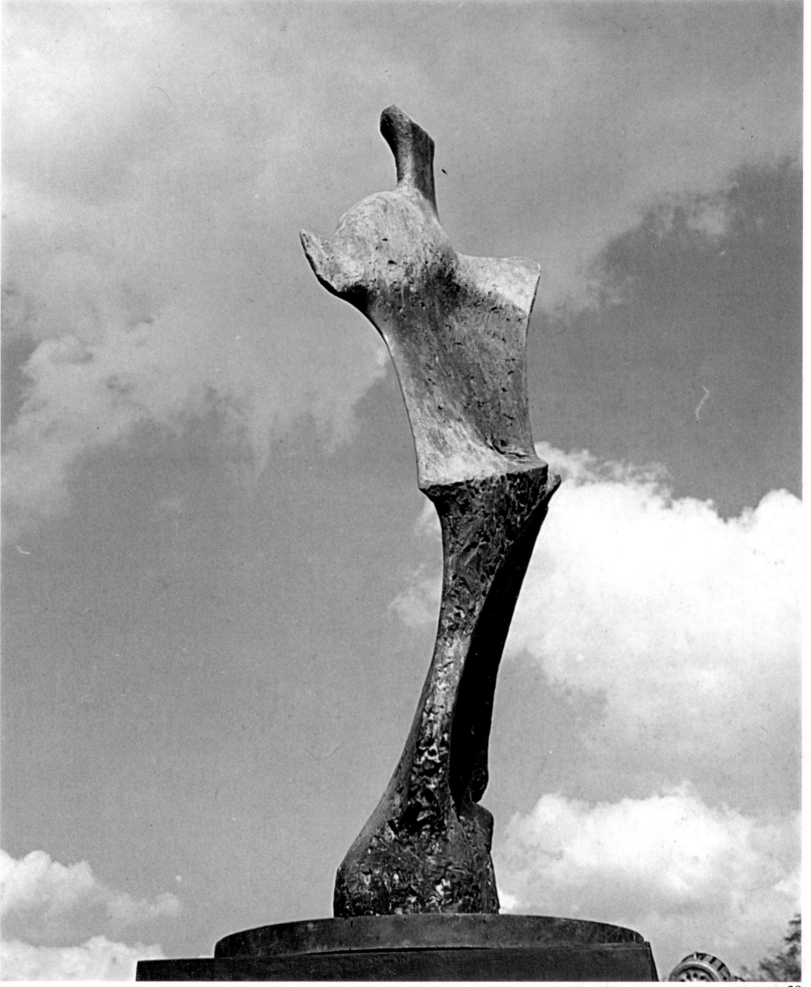

29

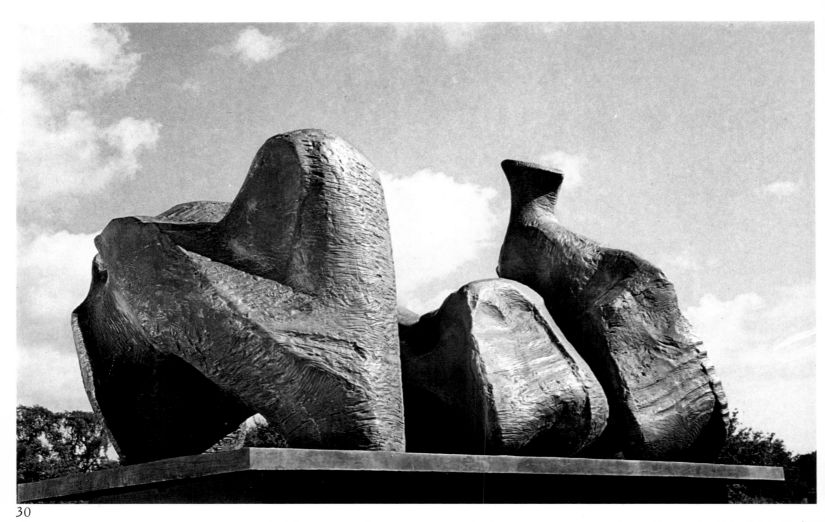

30

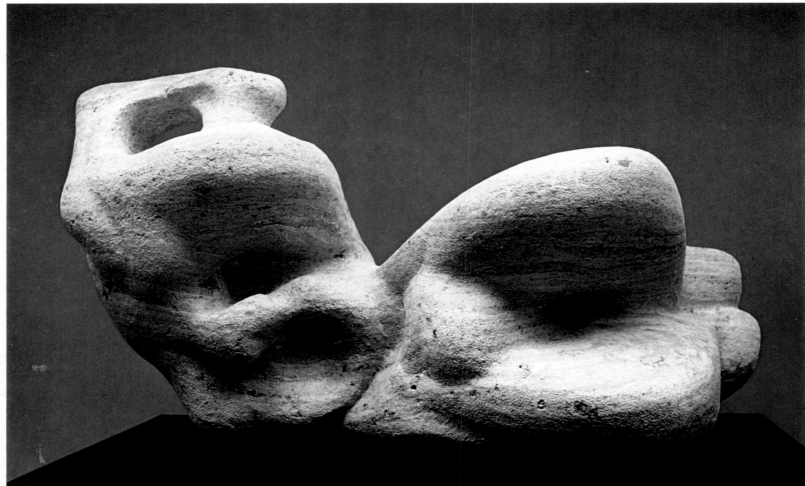

31

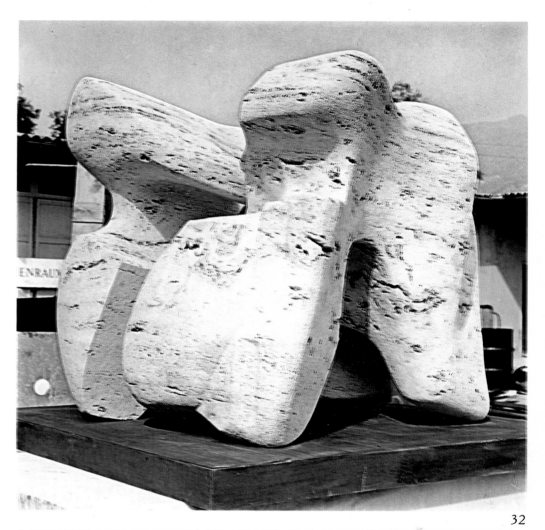

32

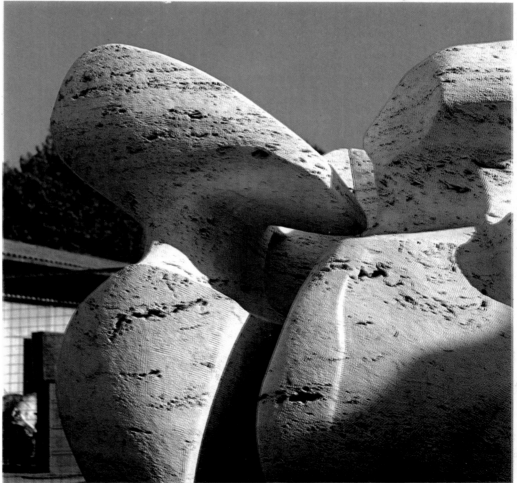

33

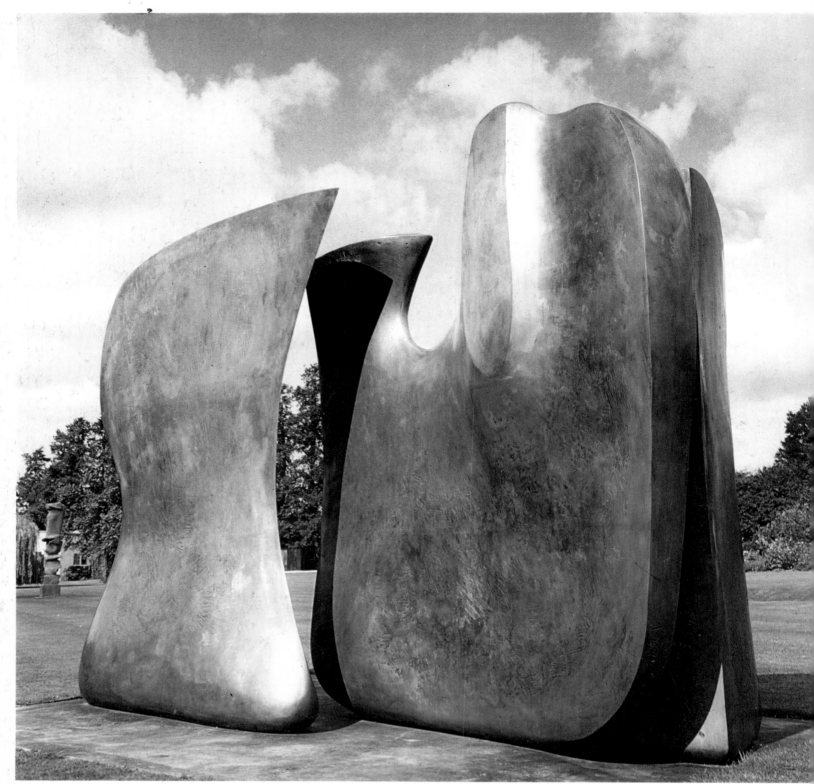

34

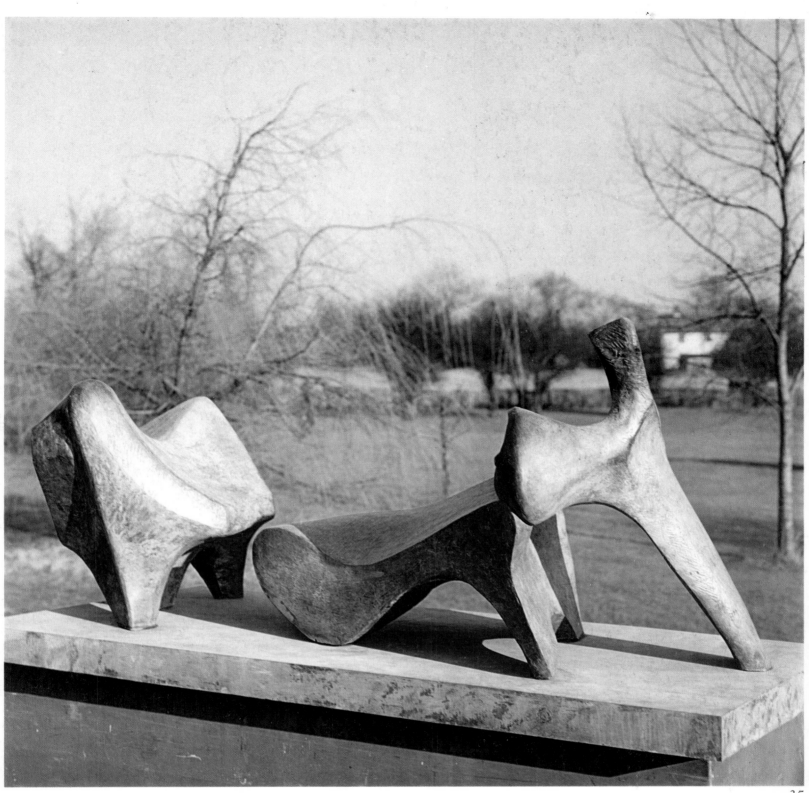

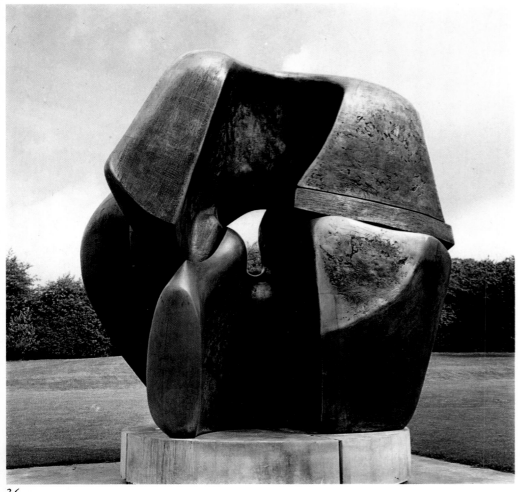

36

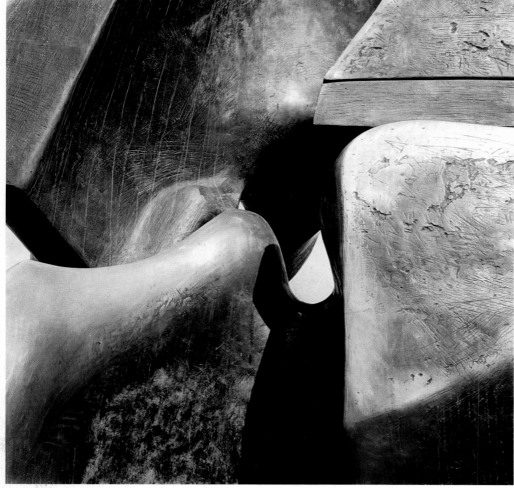

37

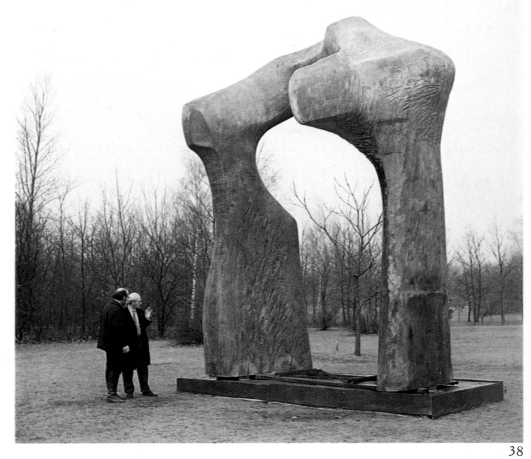

38

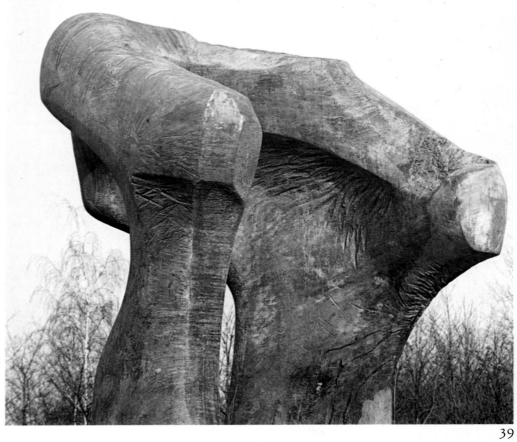

39

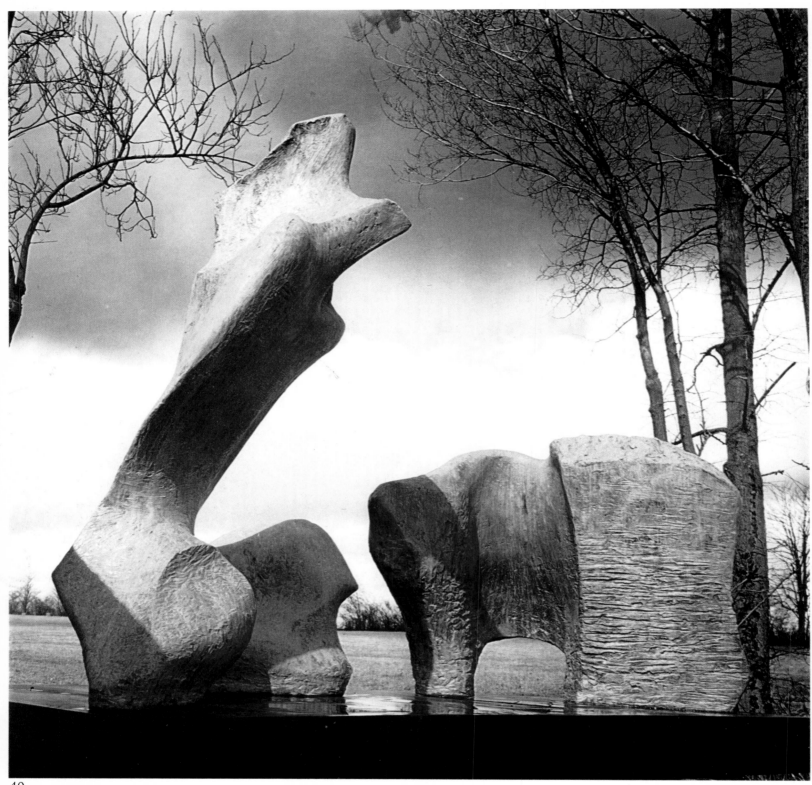

40

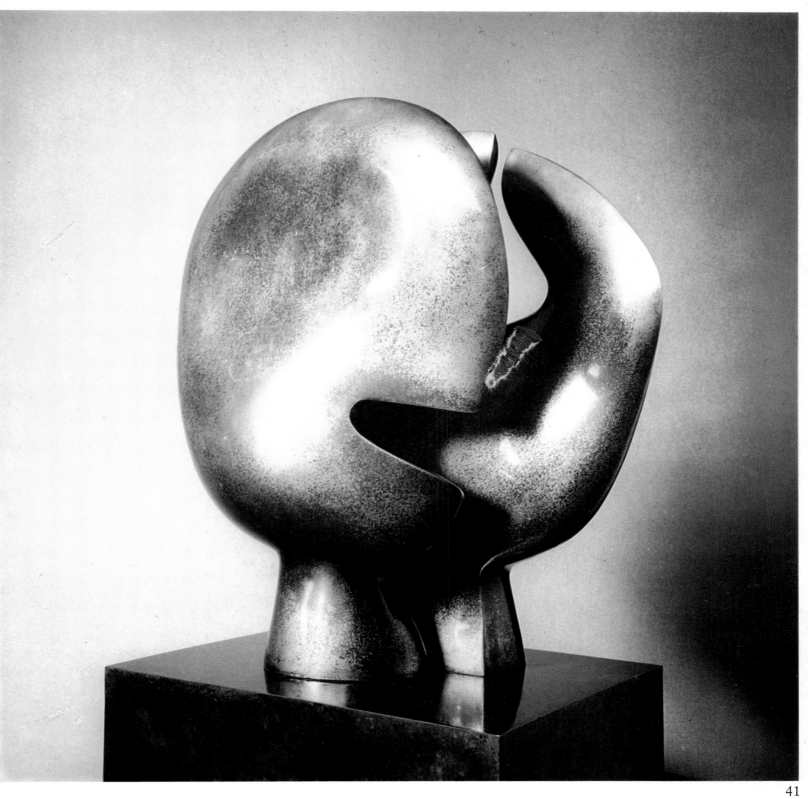

41

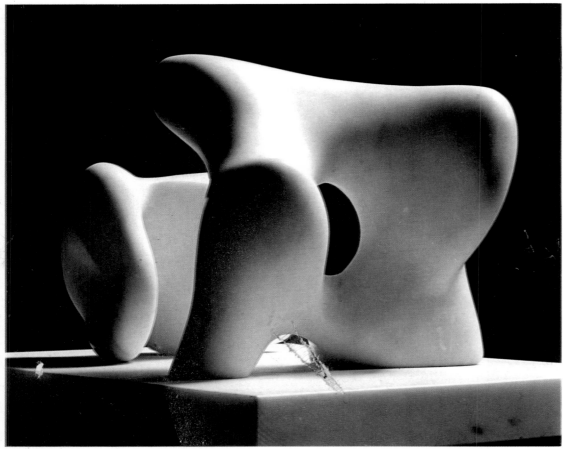

42

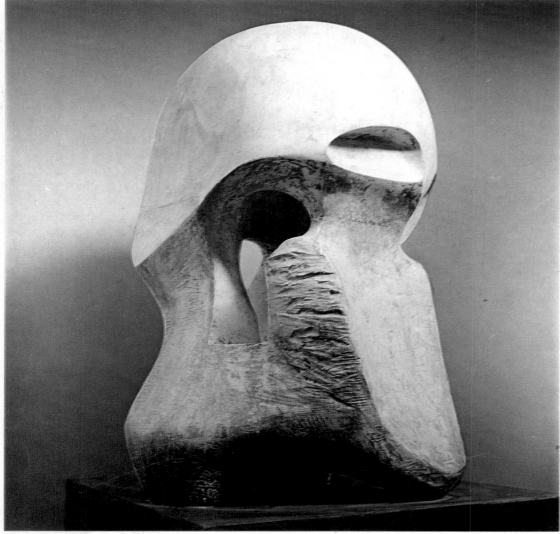

43

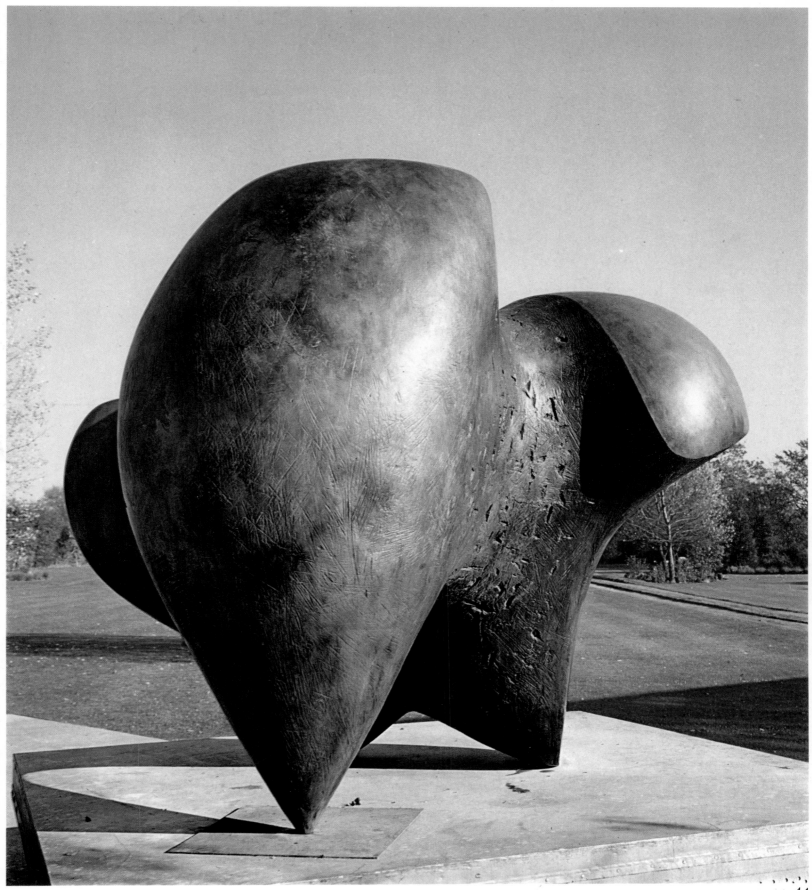

44

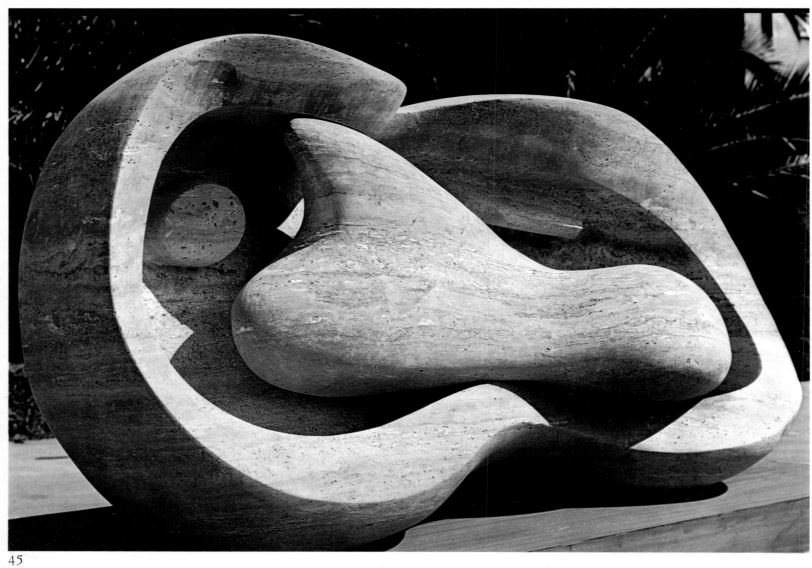

45

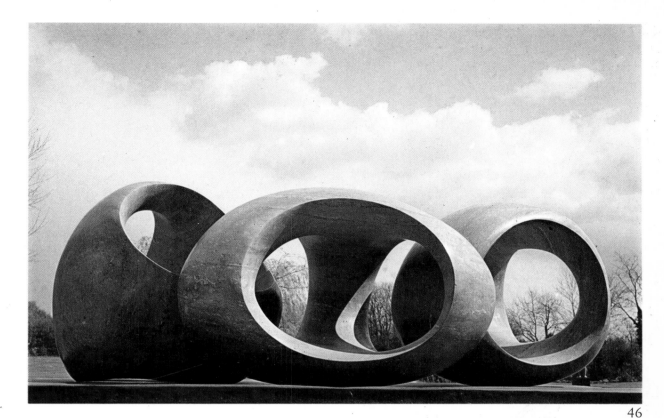

46

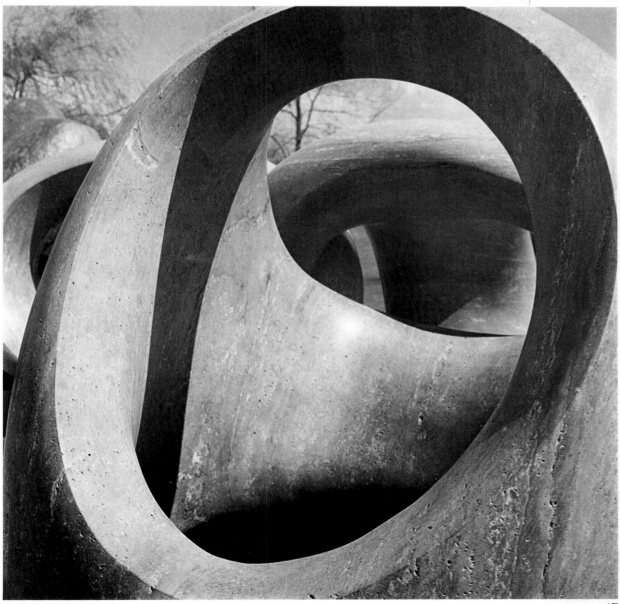

47

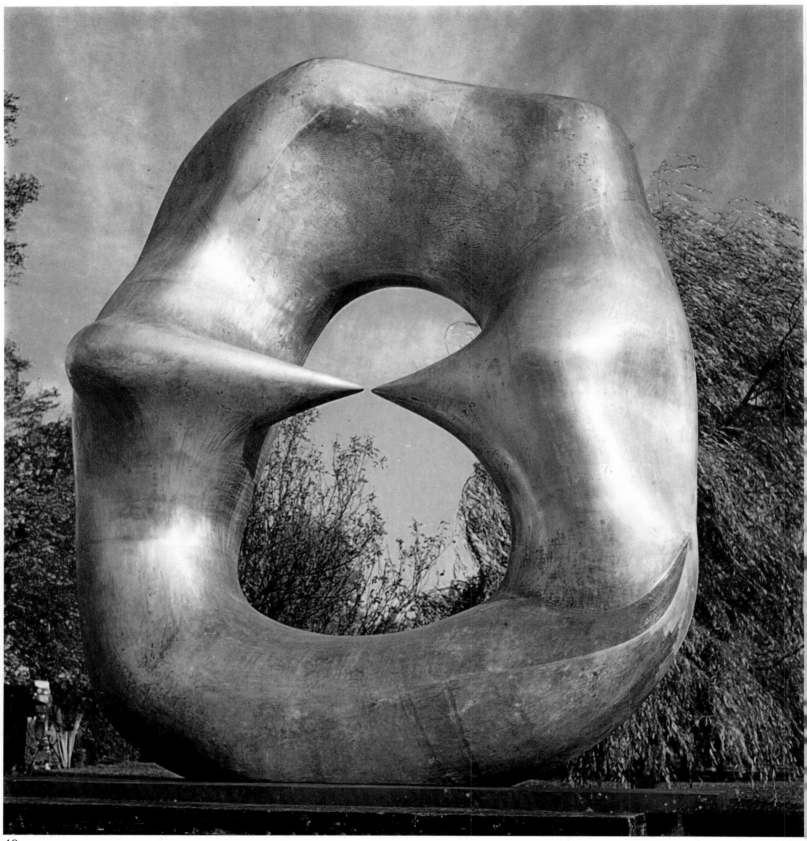

48

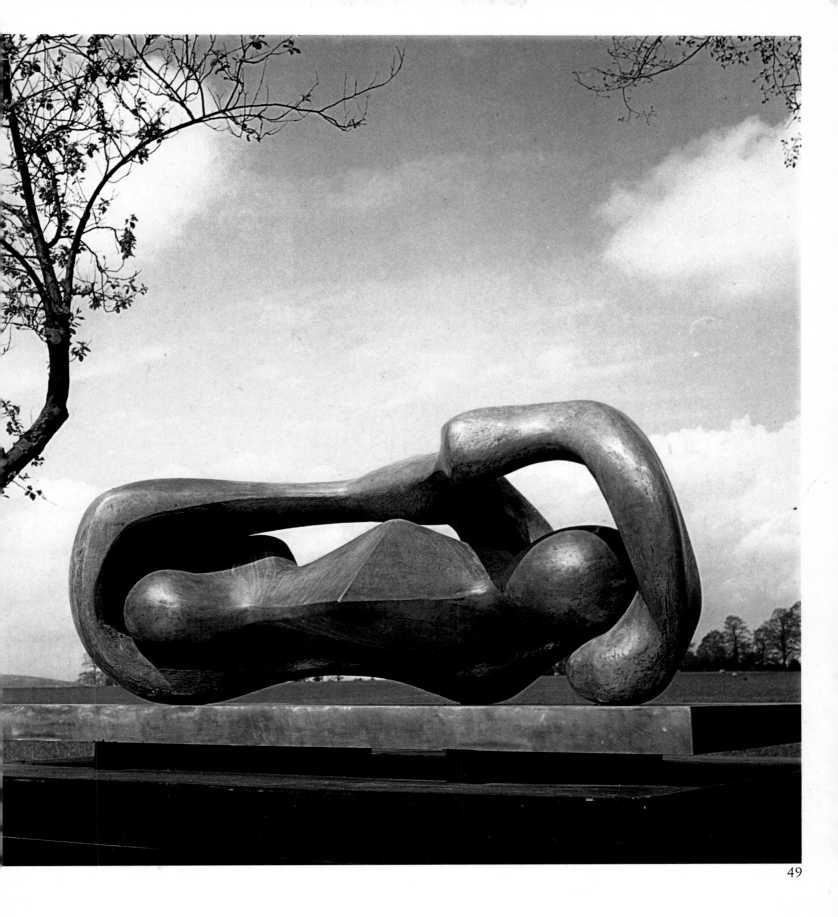

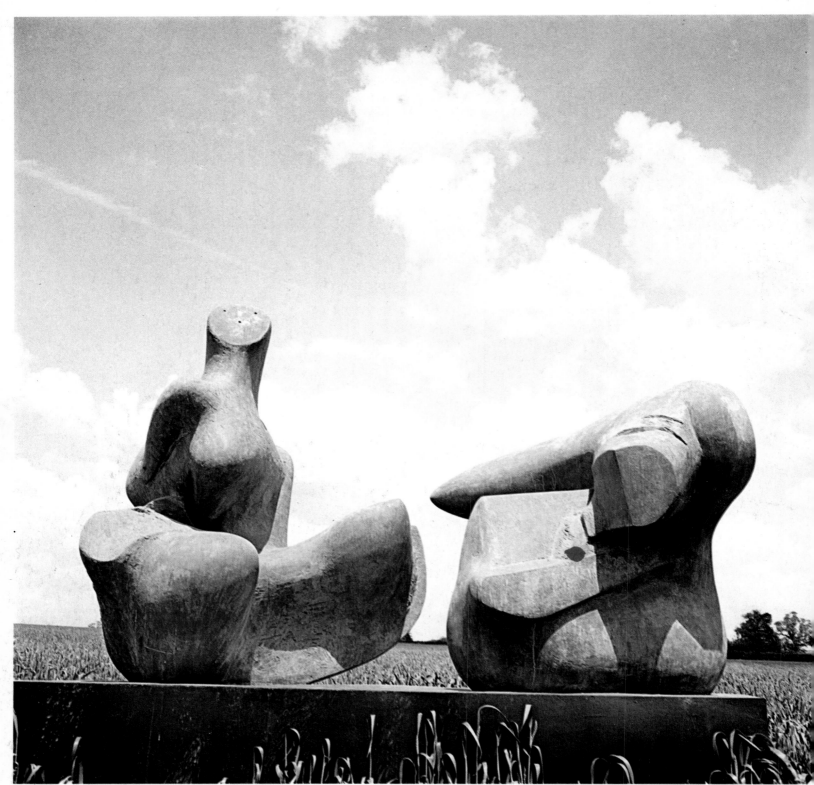

50

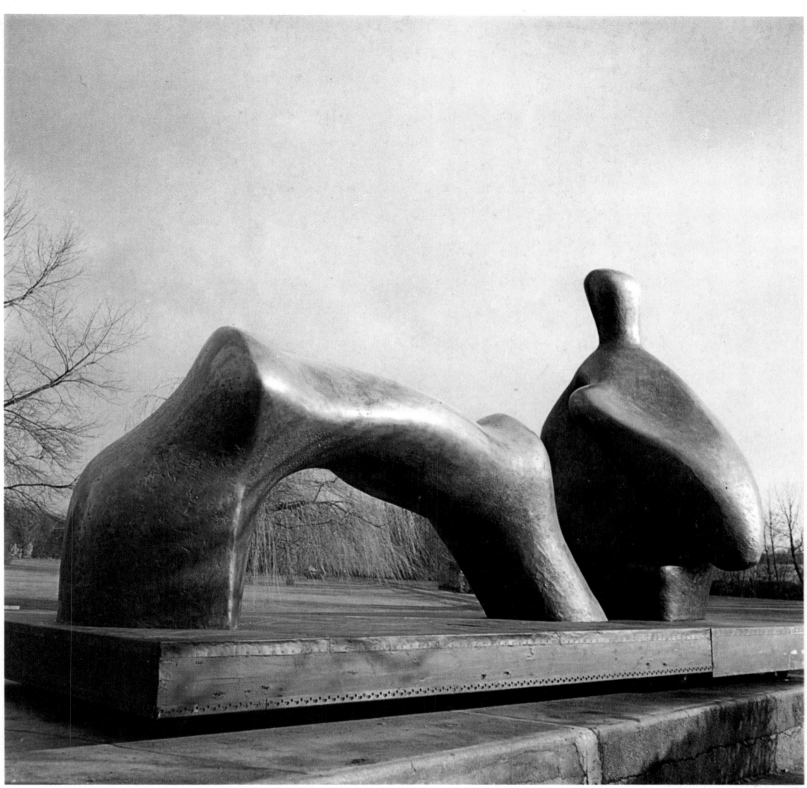

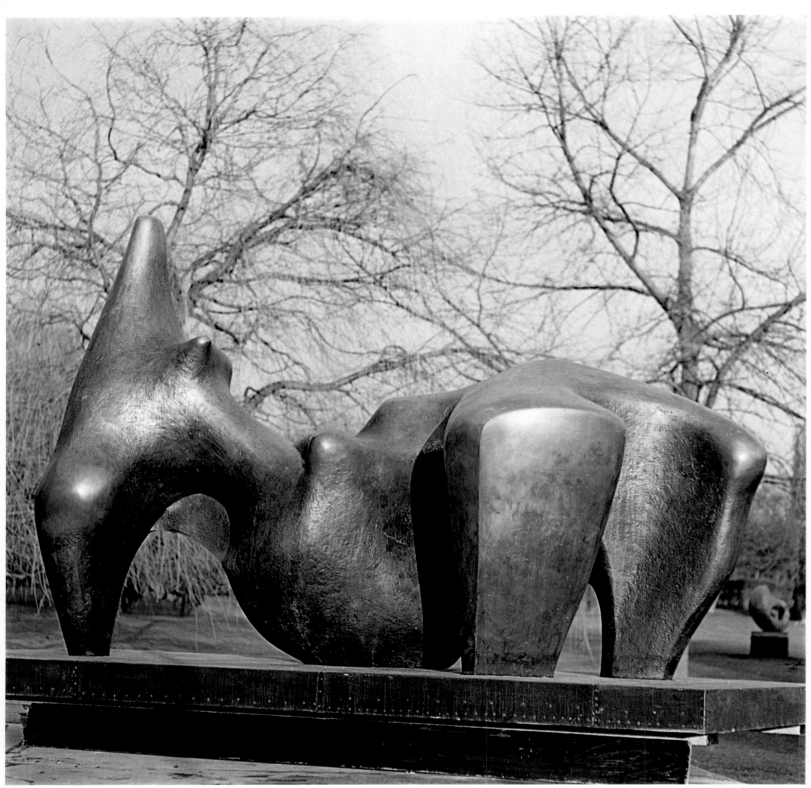

52

Description of colour plates

1 *Figure*
1923, stone
Mrs. Dorothy Elmhirst collection, Totnes

2 *Composition*
1931, green Hornton stone
Miss Mary Moore collection, Much Hadham

3 *Reclining Figure*
1938, lead
Museum of Modern Art, New York

4 *Bird Basket*
1938, lignum vitae and string
Mrs Irina Moore collection, Much Hadham

5 *Stringed Figure*
1939, lead and string

6 *Stringed Figure*
1939, lead and wire
Mrs Irina Moore collection, Much Hadham

7 *Reclining Figure*
1939, elm wood
Institute of Arts, Detroit

8 *Reclining Figure* (detail)

9 *Three Points*
1939–40, cast iron
Mrs Irina Moore collection, Much Hadham

10 *Family Group*
1945, bronze (7 casts)

11 *Reclining Figure*
1945–46, elm wood
Cranbrook Academy of Art, Bloomfield Hills, Michigan

12 *Reclining Figure* (detail)

13 *Standing Figure*
1950, bronze (4 casts)
W. J. Keswick collection, Dumfries

14 *Reclining Figure*
1951, plaster model (5 bronze casts)

15 *Reclining Figure* (detail)

16 *King and Queen*
1950–53, bronze (4 casts)
Tate Gallery, London

17 *King and Queen* (detail)

18 *Internal and External Forms*
1952–53, bronze (3 casts)
Kunsthalle, Hamburg

19 *Reclining Figure No. 2*
1953, bronze (7 casts)

20 *Family Group*
1954–55, Hadene stone
Harlow New Town, Essex

21 *Upright Motif No. 1; Glenkiln Cross*
1955–56, bronze (6 casts)
Folkwang Museum, Essen

22 *Mother and Child with Apple*
1956, bronze (10 casts)

23 *Mother and Child with Apple* (detail)

24 *Fallen Warrior*
1956–57, bronze (10 casts)
Clare College, Cambridge

25 *Fallen Warrior* (detail)

26 *Seated Woman*
1957, bronze (6 casts)

27 *Reclining Figure*
1959–64, elm wood

28 *Reclining Figure* (detail)

29 *Standing Figure: Knife Edge*
1961, bronze (7 casts)
Frank Stanton collection, New York

30 *Three Piece Reclining Figure No. 1*
1961–62, bronze (7 casts)

31 *Reclining Figure*
1961–69, yellow travertine
Sir Max and Lady Raynes collection

32 *Stone Memorial*
1961–69, travertine
National Gallery, Washington

33 *Stone Memorial* (detail)

34 *Knife Edge, Two Pieces*
1962–65, bronze (3 casts)

35 *Three Piece Reclining Figure No. 2*
1963, bronze (6 casts)

36 *Locking Piece*
1963–64, bronze (3 casts)
Bank Lambert, Brussels

37 *Locking Piece* (detail)

38 *The Arch*
1963–69, bronze

39 *The Arch* (detail)

40 Model for *Reclining Figure*
1963–65, bronze (2 casts)
Lincoln Centre

41 *Moon Head*
1964, bronze (9 casts)

42 *Two Forms*
1964, white marble
Chichester cathedral

43 *Atom Piece*
1964–65, plaster

44 *Three Way Piece No. 1: Points*
1964–65, bronze (3 casts)

45 *Interior Oval*
1965–68, red travertine
Mrs Robert Levi collection, Maryland

46 *Three Rings*
1966, red travertine
Mrs Robert Levi collection, Maryland

47 *Three Rings* (detail)

48 *Oval with Points*
1968–70, bronze (6 casts)

49 *Reclining Connected Forms*
1969, bronze (9 casts)

50 *Two Piece Reclining Figure: Points*
1969–70, bronze (7 casts)

51 *Reclining Figure: Arch Leg*
1969–70, bronze (6 casts)

52 *Reclining Figure*
1969–70, bronze (6 casts)

Biographical outline

1898. Henry Moore, son of Raymond Spencer Moore, a former miner, and Mary Baker, is born on 30th July at Castleford, at that time a village of about 25,000 inhabitants, near Leeds in Yorkshire.

1910. He attends the elementary classes of Castleford Grammar School where he receives his first encouragement to draw from the art teacher Miss Alice Gostick. He wins a scholarship to the senior school.

1915. He becomes a master in a primary school. Despite his own ambition to be a sculptor he follows his father's wishes in becoming a schoolmaster.

1917–18. In February 1917 he enlists. By the summer he is in France. Towards the end of the year, in the Battle of Cambrai he is gassed and sent to a hospital in London.

1919. Demobilised in February, he returns to teaching. Wins a scholarship to attend the Leeds School of Art. In Leeds Public Library he discovers the book *Vision and Design* by Roger Fry, which is to prove most useful to him. He makes the acquaintance of Michael Sadler, then Vice-chancellor of the university who was buying Cézannes and Gauguins even before 1914.

1921. Wins an entrance scholarship to the Royal College of Art, beginning in September. There he makes friends with such important people as Leon Underwood and Sir William Rothenstein. As he lives in London he is able to make frequent visits to the British Museum.

1922. He spends his holidays in Norfolk where he begins to work in the open air. Makes his first sculptures free of academic influences.

1923. He travels to Paris, the first of many journeys.

1924. He is given a travel grant, but is also nominated instructor in the school of sculpture for a period of seven years, thus bringing to an end his time as an apprentice at the College. He asks to be allowed to go to Paris instead of Italy, but is refused.

1925. He spends the first week of his journey in Paris. Then between the end of January and July visits Rome, Florence, Pisa, Siena, Assisi, Padua, Ravenna and Venice.

1926. For some months he is torn by a fierce conflict after the profound impact made on him by Italian art which he considers 'the enemy' in its entirety. He continues to teach at the Royal College in London. Participates in an exhibition at George's Gallery.

1927. Through Raymond Coxon he meets John Piper and others. He forms a group of young painters and sculptors who exhibit at the Beaux-Arts Gallery.

1928. First show at the Warren Gallery, London. He sells works for £90. Among the buyers are Jacob Epstein, Augustus John and Henry Lamb. Following a harsh review in the *Morning Post* where it was held immoral that a sculptor such as Moore should teach the young, his teaching colleagues ask for his resignation. Sir William Rothenstein, President of the Royal College, defends him. He receives his first public commission, a bas-relief in stone for the underground station at St James's, London. Becomes a friend of Herbert Read, another Yorkshireman and at that time a keeper in the Victoria and Albert Museum.

1929. He marries Irina Radetsky, a student of painting at the Royal College.

1930. Becomes a member of the Seven and Five Society, until 1935, along with Nicholson, Hepworth, Hitchens, Staite Murray and Piper. In May he publishes his first article, 'A view of sculpture'.

1931. In October he participates in a collective exhibition at Tooth's Gallery, London, 'Recent Developments in British Painting'. In November, he exhibits at the Lefevre Gallery in 'Young British Artists'. In December 1931–January 1932, in 'Watercolours and Drawings' at Abdy and Co., London.

1932. Exhibits in February with the Seven and Five Society at the Leicester Galleries, in April, at the 'Room and Book' exhibition at the Zwemmer Gallery, London. From 1932 till 1939 he teaches sculpture at the Chelsea School of Art. A personal exhibition at the Leicester Galleries.

1933. He participates in February in the Seven and Five Society

show at the Leicester Galleries. In April in the 'Recent Paintings by German, French and English artists', at the Mayor Gallery, London; in May–June in 'Artists of Today', at the Zwemmer Gallery; in October–November in 'Art Now', at the Mayor Gallery. Becomes a member of the Unit One group, founded by Herbert Read. Personal exhibition at the Leicester Galleries, London.

1934. Shares in the Unit One exhibition at the Mayor Gallery (April), also in the group's various exhibitions in the Walker Art Gallery, Liverpool; Platt Hall, Rusholme; City Art Gallery and Museum, Hanley. He leaves Balfreston, the Kent village in which he had lived since 1931, for a cottage with a huge field at Kingston, near Canterbury. He works there with Bernard Meadows as his assistant.

1935. Participates in 'French and English Contemporary Artists' at the Zwemmer Gallery, London; in October in an exhibition of the Seven and Five Society at the Zwemmer Gallery. Personal exhibition of his drawings at the same gallery.

1936. Participates in 'Fantastic Art, Dada and Surrealism' at the Metropolitan Museum, New York; in 'Cubism and Abstract Art' at the same museum; in 'Abstract and Concrete' in February in Oxford and subsequently in London, Cambridge, and Liverpool; 'Abstract Art in Contemporary Settings' at the Duncan Miller Ltd., in London; in the 'International Surrealist Exhibition' at the New Burlington Galleries, London. Goes abroad to see the prehistoric caves in the Pyrenees, also visiting Madrid, Toledo and Barcelona. Is commissioned by the architect Serge Chermayeff to make a sculpture for his home at Halland, Sussex. He meets Gropius, who was building the primary school at Impington, who requests a sculpture for the new edifice. Realisation of his Family Group is postponed for lack of money. Collaborates in Read's manifesto, Surrealist in feeling. Personal show at the Leicester Galleries, London.

1937. Initiates the figures with children. John Piper reviews the works of Moore and other artists. Collaborates in the *International Survey of Constructive Art* edited by Naum Gabo, Ben Nicholson and Leslie Martin. Participates in the 'Surrealist section, Artists' International Association' in London, April–May; and in June, in the 'International Exhibition of Surrealism' at the Nippon Salon, Tokyo. Also in 'Constructive Art' at the London Gallery in July; 'Watercolours by modern English and French Artists' at the Mayor Gallery; and 'Surrealist Objects and Poems' at the London Gallery.

1938. Participates in 'Contemporary Sculpture' at the Guggenheim Jeune, London (April–May); the 'Exposition Internationale du Surréalisme' at the Galerie Robert in Amsterdam.

1939. He gives up teaching and lives in Kingston. Exhibits at the collective 'Living Art in England', London Gallery (January–February) and at the 'Contemporary British Artists' show, Leicester Galleries, London (October–November). Personal show of graphic work at the Mayor Gallery, London.

1940. Returns to his London studio in August. Decides to make his own contribution to the war activities. Enrols at the Polytechnic to learn to build precision machinery. During an air-raid observes the forms of people taking refuge in the underground. Begins his drawings of the refugees. Kenneth Clark sees the drawings and at once persuades the War Artists Committee to buy some of them. Works as an official war artist. Completes about a hundred large drawings and two sketchbooks. Exhibits in the collective 'England Today' show in Sydney and Melbourne, Australia, and in 'Surrealism Today' at the Zwemmer Gallery. His London studio is partially destroyed; he settles at Much Hadham.

1941. He is elected a member of the Tate Gallery Commission for a period of seven years. Has a personal show at Temple Newsam in Leeds.

1942. Makes drawings of miners, following a suggestion of Herbert Read, and so pays a visit to the mines at Castleford, his birthplace, where he stays for two weeks. The first male figures of Moore's oeuvre begin to appear.

1943. Is commissioned to do a Madonna and Child for St Matthew's church, Northampton, by its vicar Rowden Hussey, for the same church, in fact, that Sutherland was to make a Crucifixion and Benjamin Britten a Solemn Cantata. Begins models for the Madonna.

Also initiates models for the Family Group at Impington, but further financial difficulties develop. Has a show at the Buchholz Gallery, New York.

1944. Makes a series of sketches and drawings for the Family Group. Makes a study of bronze casting and thereafter works with plaster and wax as the most malleable materials.

1945. He is created Honorary Doctor of Literature of Leeds University. Travels, in November, to Paris. Makes some Reclining Figures. Personal exhibition of drawing and sculpture at the Berkeley Galleries, London.

1946. Makes other sketches for the Family Group. Executes the *Memorial Figure* in Dartington, and the terra-cotta model of Three Standing Figures. His daughter Mary is born. Personal exhibitions at the Leicester Galleries, London and the Phillips Memorial Gallery in Washington. A major retrospective exhibition, also, at the Museum of Modern Art, New York (58 sculptures, 48 drawings). Leaves for New York.

1947. Is commissioned to sculpture a Madonna and Child for Claydon church, Suffolk. Also receives a commission from John Newson, Director of Education for Hertfordshire, for a sculpture for Barklay School, Stevenage, a modern, functional building. Moore chooses one of the models elaborated in 1945 for the Family Group. Personal show at Chicago Art Institute (same works as New York), the Museum of Modern Art in San Francisco, the National Gallery of New South Wales in Sydney and the Tasmanian Museum and Art Gallery, Hobart. Also exhibits at the National Victoria Gallery in Melbourne, the National Gallery of South Australia in Adelaide, and at the National Gallery of Western Australia, Perth.

1948. Finishes *Three Standing Figures,* which is bought by the Contemporary Art Society. It is shown for the first time in Battersea Park, the first open-air exhibition held by London County Council. Wins first prize with the same work at the XXIV Venice Biennale. Visits Florence, Pisa and Venice. Is elected a member of the Royal Fine Art Commission. Elected honorary associate of the Royal Institute of British Architects. Elected a representative foreign member of the Academy Royale Flamande des Sciences, Lettres et Beaux-Arts de Belgique. Personal shows at the Arts Council, Cambridge, the English pavilion and the XXIV Venice Biennale (36 sculptures and 33 drawings), at the Galleria d'Arte Moderna, Milan and at Roland Browse and Delbanco, London.

1949. Finishes *Family Group* for Stevenage, and attends its casting in person. Other castings were made by Rudier in Paris. He is re-elected to the board of commissioners at the Tate Gallery for a further seven years. Visits Brussels, Amsterdam and Berne. Personal exhibitions at the City Art Gallery, Wakefield; the City Art Gallery, Manchester; the Palais des Beaux-Arts in Brussels and the Musée National d'Art Moderne in Paris.

1950. An exhibition mounted by the British Council (53 sculptures and 44 drawings) is shown at the Stedelijk Museum, Amsterdam; the Kunsthalle, Hamburg; the Staatischen Kunstsammlungen, of Dusseldorf; the Kunsthalle, Berne; and the Gallery of Mexican Art, Mexico City.

1950–51. Engaged on several sculptures, he also begins a Reclining Figure for the Festival of Britain organised by the Arts Council of Great Britain. One cast is acquired by the Musée National d'Art Moderne in Paris. Develops ideas that had first appeared in drawings of 1940.

1951. First model and cast of Internal and External Forms. Journey to Greece: he visits Athens, Mycenae, Olympia, Corinth and Delphi. Elected foreign member of the Royal Swedish Academy of Fine Arts. Participates in the 'Second International Exhibition of Open-air Sculpture' in Battersea Park and the 'First International Open-air Exhibition of Sculpture' at Middelheim Park, Antwerp. Personal exhibitions at the Zappeion Gallery, Athens; the Tate and Leicester Galleries, London; the Hans am Waldsee, Berlin; the Buchholz Gallery, New York and the Albertina in Vienna.

1952. He is commissioned to execute a parapet (more than 10 feet high and 26 feet long) for the façade, and a Draped Reclining Figure for the square of the new Time-Life block in London. Participates

30 Henry Moore in 1970

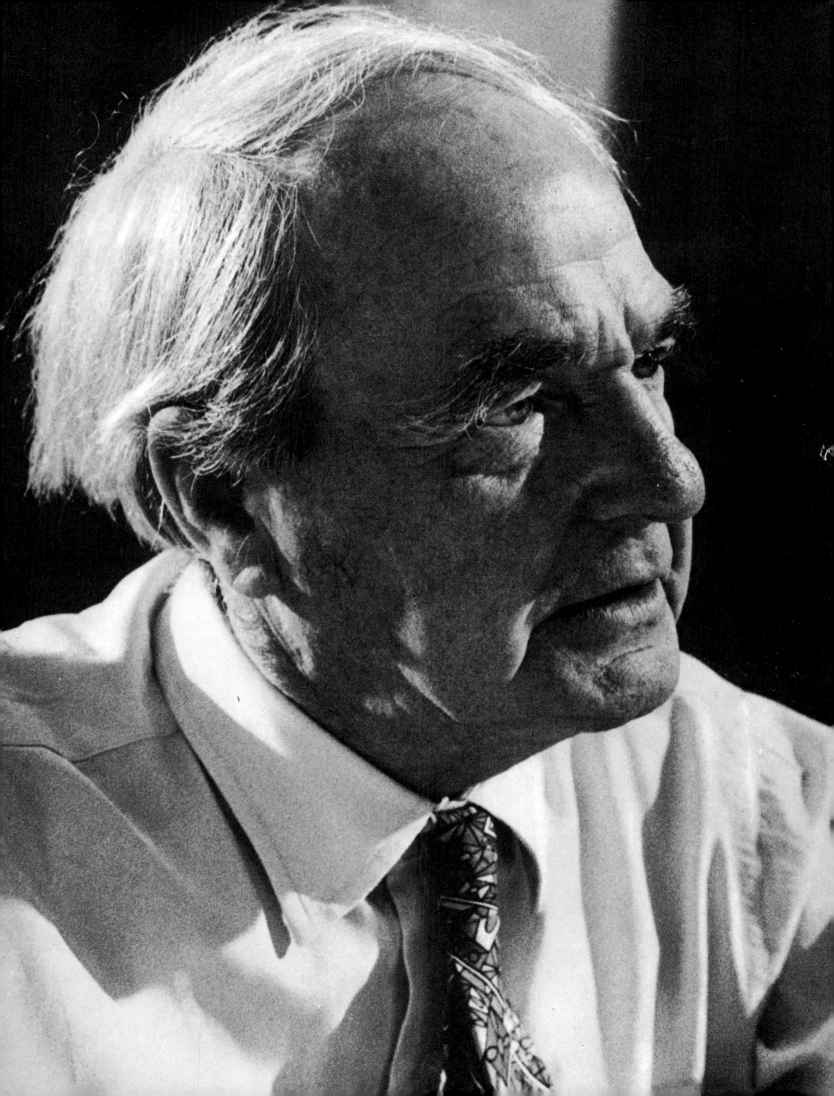

in the International Conference of Artists organised by UNESCO in Venice. Visits Florence and Rome. Personal shows at the National Gallery of South Africa (Van Riebeeck Tercentenary Celebrations) in Cape Town; at the Akademien (under the auspices of the Riksforbundet for Bildande Konst) in Stockholm; at the Akademien in Norrköping, and the Akademien in Örebro; the Kunstmuseum, Göteborg; the Neue Galerie der Stadt Linz in Austria; the Samlaren Gallery, Stockholm; the Akademien Kunstnernes Hus in Oslo; the Kunstforeningen, Bergen and the Boymans van Beuningen Museum, Rotterdam.

1953. Elected Honorary Doctor of Literature of London University. Re-elected Member of the Royal Fine Art Commission. He wins the First International Sculpture prize at the Second Biennale Exhibition in São Paolo, Brazil. Travels in Brazil and Mexico. Exhibits at the 'Second International Open-air Sculpture Exhibition' in Middleheim Park, Antwerp; at the 'Second International Open-air Sculpture Exhibition' in Villa Mirabello, Varese and at the open-air sculpture exhibition in the Harvestehuder Weg, Hamburg. He holds personal shows in Copenhagen, Oslo, Trondheim, Bergen and Rotterdam, organised by the British Council. Other personal exhibitions at the Institute of Contemporary Arts, London; the Comite Voor Atristieke Werking, Antwerp; the Kestner Gesellschaft, Hanover; the Kunsthaus, Munich; the Stadelsches Kunstinstitut, Frankfurt; the Staatsgalerie, Stuttgart, and the British section of the Second International Biennial in São Paolo, Brazil.

1954. Is commissioned to execute a brick relief for the façade of the new Bouwcentrum in Rotterdam (actually completed in 1955). Visits Milan, Venice, Rome, Rotterdam and Hanover. Exhibits at the 'Third International Show of Sculpture in the Open Air' at Holland Park, London organised by the British Council. Personal shows at the Leicester Galleries, London; at the Kunsthalle, Mannheim and Bremen, at the Senat für Volksbildung in Berlin; the Stadverwaltung in Göttingen and the Curt Valentin, New York.

1955. Elected honorary member of the American Academy of Arts and Sciences. Re-elected member of the Art Panel of the Arts Council. Nominated Trustee of the National Gallery. Elected member of the Order of the Companions of Honour. Exhibits at the 'Third International Sculpture Exhibition in the Open Air', in Middelheim Park, Antwerp; at the 'Third International Open-air Exhibition of Sculpture' in Sonsbeek Park, Arnhem; and at the show 'Documenta I' in Kassel. Visits Jugoslavia, the Ruhr and Holland on two journeys. Personal shows at the Kunsthalle, Basle; the University of Colorado in Boulder and the Colorado Springs Fine Arts Centre, the Denver Art Museum, the University of Wyoming and in the Museum in Zagreb. Other exhibitions organised by the British Council in Belgrade, Skopje and Ljubljana.

1955–58. Retrospective exhibitions of sculpture and drawings organised by the British Council in the principal centres of Canada, New Zealand, and South Africa; Museum of Fine Arts, Montreal; National Gallery of Canada, Ottawa; Toronto Art Gallery; Winnipeg Art Galleries' Association; Vancouver Art Gallery; Auckland City Art Gallery; Canterbury Society of Arts, Christchurch; Public Art Gallery, Dunedin; National Art Gallery, Wellington; King George VI Art Gallery, Port Elizabeth; Rhodes National Gallery, Salisbury; National Museum, Bulawayo; and Johannesburg Art Gallery.

1956. Is commissioned to do a sculpture for the new UNESCO building in Paris. Re-elected Trustee of the National Gallery for seven years. Visits Holland. Participates in collective shows in the Ruhrfestspiel, Recklinghausen, and the 'First International Exhibition of Contemporary Sculpture' in the Musée Rodin, Paris.

1957. Is awarded the Stefan Lochner medal by the City of Cologne. Visits Italy. At Querceta sculptures the Reclining Figure for UNESCO. Exhibits at the 'Fourth International Open-air Sculpture Exhibition', and at the 'First Contemporary British Open-air Sculpture Exhibition', both in Holland Park, London; also at the 'First Contemporary British Sculpture Exhibition' at the Arts Council, London. Personal shows, besides those in America, at the Berggruen Gallery, Paris and at Roland, Browse and Delbanco, London.

1958. Elected President of the Auschwitz Memorial Committee. Elected Honorary Doctor of Arts at Harvard University. Wins the Second prize for sculpture in the Carnegie International in Pittsburg. Visits Poland, France, the United States (New York and San Francisco). Exhibits at the 'Fourth Open-air Sculpture Exhibition' in Sonsbeek Park, Arnhem. Exhibits at the show 'Fifty Years of Modern Art' at the International Fair in Brussels and at the Galleria Blu Milan. Also at the Marlborough Gallery, London. Personal shows at the Hatton Gallery, Newcastle-upon-Tyne.

1959. Elected Honorary Doctor of Literature at the University of Reading; elected Honorary Doctor of Law at Cambridge University. Wins the International Sculpture Prize at the Biennale in Tokyo. Elected Academico Correspondiente by the Academia Nacional de Bellas Artes in Buenos Aires. Wins a gold medal from the Society of Friends of Art in Krakow, Poland. Participates in the collective shows: Fine Art Associates Gallery, New York; Second 'Biennale Internazionale di Scultura' in Carrara; Middelheim Park, Antwerp; Kroller-Muller Museum, Otterlo; 'Documenta II, Kassel; Musée Rodin, Paris; Arts Club, Chicago. Presents a retrospective of drawings and sculpture organised by the British Council for cities in Portugal and Spain; Palacio Foz, Lisbon; Escola de Bellas Artes, Oporto; Galleria Biblioteca Nacional in Madrid; Ospedale di Santa Cruz, Barcelona. Exhibition of his works from 1950–58 organised by the British Council for the Fifth International Exhibition at the Metropolitan Art Gallery, Tokyo, where Moore receives the Foreign Minister's Prize; the exhibition is given in other Japanese cities; Sogo Department Store, Osaka; Art Gallery of Takamatsu; Art Gallery of Yawata City; Fukuya department store, Hiroshima; Daimaru department store, Fukuoka; the City Hall, Ube; Saseho and Nakamura department store, Nakamura.

1959–60. Retrospective show of sculpture and drawings, 1927–58, organised by the British Council for the Central Office of Art Exhibitions for the Polish Ministry of Culture, at the Zachenta Gallery in Warsaw; the Society of Fine Arts in Krakow; the Central Ministry of Art Exhibitions in Wroclaw; the National Museum in Poznan and the Museum of Pomerania in Szczetcin.

1960. Begins the second great Reclining Figure in two pieces. Participates in international sculpture exhibitions in the Boymans van Beuningen Museum, Rotterdam; in Battersea Park, London; and at Gressoney and Turin. Visits Germany, Switzerland and Holland. Re-elected to the Royal Art Commission. Personal show at the Whitechapel Gallery, London (73 sculptures 1950–60).

1961. Elected Honorary Member of the American Academy of Arts and Letters. Honorary Doctor of Literature at Oxford University. Member of the Kunst Akademie in Berlin. Travels in France and Italy. Participates in collectives at: the Musée Rodin, Paris; 'Second International Exhibition of Contemporary Sculpture'; Middelheim Park, Antwerp; the National Museum of Wales in Cardiff; the Marlborough Fine Art Gallery in London and the Scottish National Gallery of Modern Art, Edinburgh. Between 1960 and 1962 a retrospective exhibition of his work visits various German cities, organised by the British Council: the Kunsthalle in Hamburg and then in slightly altered form in Essen, Zurich, Munich, Rome, Paris, Amsterdam, Berlin, Vienna, and Louisiana.

1961–63. Participates with five other sculptors in 'Recent British Sculpture' organised by the British Council for a tour of main centres in Canada, New Zealand and Australia.

1962. Elected Honorary Doctor of Engineering by the Technische Hochschule in Berlin and Honorary Doctor of Letters at Hull University. Is commissioned to do a large, two-piece sculpture in bronze for the Reflecting Pool at the Lincoln Center, New York. Elected Honorary Fellow of Lincoln College, Oxford. Nominated member of the National Theatre Board. Visits New York, then Sweden and Germany. Participates in the following shows: 'Art Since 1950' organised by Seattle World's Fair; at the Ca' Pesaro in Venice; at the 'Third Biennial International Sculpture Exhibition' in Carrara; at Keukenhof Park in Lisse, Holland; at the Spoleto Festival; at the Museum des 20 Jahrhunderts in Vienna ('Kunst von 1900 bis Heute'); at the National Museum of Wales ('British Art and the Modern Movement 1930–40') in Cardiff; at the Museum

of Art, San Francisco ('British Art Today', moving on later to Dallas and Santa Barbara). Has several personal exhibitions: at the Arts Council Gallery, Cambridge, organised by the British Council and transferring later to New York and the Marlborough Fine Arts in London, the Ashmolean Museum in Oxford. Starts work on *Locking Piece*.

1963. He is awarded the Antonio Feltrinelli Prize for sculpture by the Accademia dei Lincei in Rome, and goes there to receive it from the President of the Italian Republic in December. Elected member of the Order of Merit. Elected honorary member of the Society of Finnish Artists. Travels in Italy, Germany and Jugoslavia. Participates in the following exhibitions: Battersea Park, London; Brook Street Gallery, London; the Gallery of Modern Art, Washington ('Sculpture of Our Time'). Personal show with 55 drawings 1929–62 in Reinickendorf which then transfers to Tempelhof (Berlin), Munich, Düsseldorf, and Castrop Rauxel; others at the City Art Gallery, Wakefield (and subsequently in the Ferens Art Gallery, Hull); at La Jolla Arts Centre, California (moving on later to Santa Barbara and Los Angeles); the Marlborough Fine Art, London. Starts work on the huge two-piece *Reclining Figure* for the Lincoln Center in New York; spends his holidays at Forte dei Marmi where he begins a marble sculpture that he finishes in England.

1964. Receives the Fine Arts Medal of the Institute of Architects in the USA. Elected member of the Arts Council of Great Britain; re-elected Trustee of the National Gallery. Travels in Italy, France and Belgium. Participates in the following exhibitions: Tate Gallery: Painting and sculpture of a decade 1954–64 in London, set up by the Calouste Gulbenkian Foundation; 'Exposition Surréaliste', at the Charpentier Gallery in Paris; at the Marlborough Fine Art, London; 'Four Sculptors' at the Brook Street Gallery, London; at 'Documenta III', Kassel; and at the 'First International Drawing Exhibition' in Darmstadt. Personal shows at Marlborough Fine Art (25 drawings 1942–61), London; and at the Palacio de Bellas Artes, Mexico, organised by the British Council. This was modified later and shown in Caracas, Argentina and Brazil. Another personal show at the Festival Exhibition, King's Lynn, Norfolk. Works at his sculpture for the Lincoln Center and at the full-scale version of *Locking Piece*.

1965. Buys a cottage at Forte dei Marmi because of its proximity to the quarries of Carrara where he spends the summer months. Starts work on the sundial for the Time Building and a large abstract sculpture for Chicago University. In September he is at the Lincoln Center, New York for the installation of the *Reclining Figure*. Participates in the exhibitions: 'Art in Britain 1930–40', Marlborough Gallery, London; 'Guggenheim Collection', Tate Gallery, London; 'Sculpture in the Open Air', Bezalee Museum, Jerusalem; '*Kunst in Freiheit*: Dubuffet, Moore, Tobey', Museum des 20 Jahrhunderts, Vienna; '*Arte e Resistenze in Europa*', Museo Civico, Bologna; Galleria Civica d'Arte Moderna, Torino; International Exhibition of Sculpture', Mount Philopappos, Athens; First International Biennial of Graphics', Palais des Beaux-Arts, Krakow; 'Henry Moore, Francis Bacon', Marlborough New London Gallery. Personal shows at Marlborough Fine Art, London; Orleans Gallery, New Orleans; Marlborough Galleria d'Arte, Rome; University of Arizona Art Gallery, and Arkansas Art Centre, Arkansas.

1965–66. 'Nine Living British Sculptors' touring exhibition organised by the British Council: Lalit Akademie, New Delhi; Lalit Kala Akademie, Calcutta; Rajah Hall, Madras; Jahangir Gallery, Bombay.

1966. Sculptures multiple-piece abstract forms in marble and bronze. Finishes *Nuclear Energy*. Participates in the exhibitions: Arts Council Exhibition, London; 'International Exhibition of Sculpture in the Open Air', Battersea Park, London. Personal shows at: Marlborough Fine Art, London, City Museum and Art Gallery, Folkestone; City Museum Art Gallery, Plymouth; Philadelphia College of Art, Philadelphia; 'Henry Moore 1927–64', organised by the British Council; Israel Museum, Jerusalem; Helena Rubenstein Pavilion, Tel Aviv; Delles, Bucharest; Slovak National Gallery, Bratislava; and the National Gallery, Prague.

1967. Goes to Chicago to supervise the placing of *Nuclear Energy* at the Enrico Fermi Institute. Visits several American cities. Participates in the exhibitions: 'International Exhibition of Sculpture', Terre des Hommes, Montreal; Guggenheim Museum, New York; '*Hommage à Rodin*', Galerie Lucie Weill, Paris; Carnegie Institution, Pittsburgh; XVIII Premio del Fiorino, Florence; '*Europese Beelhawrkunst in de Open Lucht*', Sonsbeek, Arnhem. Personal shows: 'Sculpture and Graphics', Cordova Museum, Lincoln; Marlborough Fine Art, London; City Art Gallery and Museum, Sheffield; 'Henry Moore 1927–64', Mucsarnock, Budapest; 'Henry Moore 1927–52', Trinity College Library, Dublin.

1966–68. 'Henry Moore', touring exhibition organised by the Smithsonian Institute: Washington, Massachusetts, Brooklyn, Atlanta, Denver, Memphis, Philadelphia, Kansas City, Minneapolis, Detroit, Utica and Winnipeg.

1967–68. 'Henry Moore 1955–64', touring exhibition mounted by the British Council for Canada: Art Gallery of Ontario, Toronto, Prince Edward Island, Confederation Centre, Charlotte Town, Arts and Cultural Centre, St John's, Newfoundland, Musée des Beaux-Arts, Montreal.

1968. He travels in America and Holland. Elected Honorary Doctor of Law at the University of Toronto; elected to the Order of Merit by the West German Federal Republic. Participates in the following exhibitions: 'British Sculptors of the Fifties', Musée des Augustins, Toulouse; Festival d'Art, Forcalquier; Palais des Beaux-Arts, Lille; London Festival. Personal show at the Tate Gallery, London. Touring exhibition organised by the British Council. Rijksmuseum Kroller-Muller, Otterlo; Kunsthalle, Düsseldorf; Boymans-van-Benningen Museum, Rotterdam; Kunsthalle, Baden-Baden.

1969. Elected Honorary Doctor of Law at Manchester University; Honorary Doctor of Letters at Warwick University; Honorary Member of the Vienna Secession, Vienna. Takes part in the following exhibitions: Gallery Gissi, Turin; 'Rosenthal Relief', Museum für Kunst und Gewerbe, Hamburg (together with Vasarely, Fontana, Pomodora, Wotruba etc.) and the National Gallery of Canada, Ottawa. Personal shows at the National Museum of Modern Art, Tokyo, Osaka, Nagoya and Hong Kong (organised by the British Council); York University; Castle Museum, Norwich.

1970. Nominated Honorary Doctor of Literature, Durham University. Takes part in exhibitions at: Marlborough Fine Art, 'Moore, Picasso, Sutherland', London. Personal shows: Marlborough and Knoedler Galleries, New York (sculpture between 1960 and 1970); Galerie Beyeler, Basle; Galerie Cramer, Geneva. Publishes a volume of 28 etchings and a text for the publishing house of Gerald Cramer, Geneva. Summer in Italy.

1971. Touring exhibition of sculpture and drawing in Persia (Teheran, Estahan and Abadan), organised by the British Council.

31 'Hoglands', Henry Moore's home in Hertfordshire

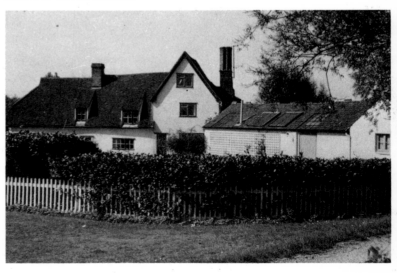

Bibliography

STATEMENTS BY HENRY MOORE

Statement in *Architectural Association Journal*, vol. XLV, n. 519, London 1930; Statement in H. READ, *Unit 1: The Modern Movement in English Architecture, Painting and Sculpture*, London 1934; 'Mesopotamian Art', in *The Listener*, vol. XIII, n. 334, London, June 1935; 'The Sculptor Speaks', in *The Listener*, vol. XVIII, n. 449, London, August 1937; 'Notes on sculpture', in *The Painter's Object*, London 1937; 'Quotations', in *Circle, International Survey of Constructive Art*, London 1937; 'Primitive Art', in *The Listener*, vol. XXV, n. 641, London, August 1941; 'The Living Image: Art and Life': discussion between V. S. Pritchett, Graham Sutherland, Sir Kenneth Clark and Henry Moore, in *The Listener*, vol. XXVI, n. 670, London, November 1941; Statement in J. J. SWEENEY, 'Henry Moore', in *Partisan Review*, vol. XIV, n. 2, New York, March–April 1947; 'Was der Bildhauer anstrebt', in *Thema*, n. 5, Monaco 1949; Statement in *Henry Moore . . . georganiseerd door the British Council* (introduction by H. Read), Amsterdam, Stedeljk Museum 1950; 'Message de la Sculpture', in *XX Siècle*, n. 1, Paris, January 1951; 'Tribal Sculpture', in *Man*, vol. LI, London, July 1951; 'Témoignage: l'espace', in *XX Siècle*, Paris, January 1952; 'Interview with Ark Magazine', in *Ark*, London, n. 6, November 1952; 'The Sculptor in Modern Society' (conference at the International Congress of Artists, Venice, September 1952) in *Art News*, vol. 5, New York, November 1952; 'Notes on Sculpture', in Ghiselin, *The Creative Process*, Berkeley and Los Angeles 1952; Statement in *Art*, December 1953; 'Extract from Letter to Canon Hussey, Northampton', in *The Country Churchman*, nn. 2, 5, May 1954; *Sculpture in the open air*, London Council Third Internation Exhibition of Sculpture, Holland Park, London, May–September 1954; 'Some notes on space and form in sculpture', in M. F. Man, *Eight European Artists*, London 1954; 'The hidden struggle', in *The Observer*, London, November 1957; *Heads, figures and ideas*, with a commentary by G. Grigson, London and Greenwich, Conn. 1958; interview in *The Observer*, April 1960, and in E. Roditi, *Dialogues on art*, London 1960; 'Jacob Epstein', commemoration in *The Sunday Times*, August 1959, and London 1962; 'Conversation with Henry Moore', in J. and V. Russell, *The Sunday Times*, December 1961; 'Moore explains his universal shapes', in J. and V. Russell, *New York Times Magazine*, New York, November 1962; 'Henry Moore talking', in D. Sylvester, *The Listener*, vol. LXX, n. 1796, London, August 1963; 'The Michelangelo Vision', interview with Henry Moore by D. Sylvester, in *The Sunday Times Magazine*, London, 16 February 1964; 'Italy', from a letter to Sir William Rothenstein, in *Henry Moore on Sculpture*, London 1966.

ARTICLES AND BOOKS

R. H. Wilensky, 'Ruminations on Sculpture: the work of Henry Moore', in *Apollo*, vol. XII, n. 72, London, December 1930; H. Read, *The Meaning of Art*, London 1931; H. Read, *The Anatomy of Art*, New York 1932; J. Epstein, preface in the catalogue of the Henry Moore private show at the Leicester Galleries, *Sculpture and drawings by Henry Moore*, London 1931; G. Delbanco, 'Henry Moore and Giorgio de Chirico', in *Die Weltkunst* vol. V, n. 17, Berlin, April 1931; H. Furst, 'Sculpture and drawings by Henry Moore at the Leicester Galleries', in *Apollo*, vol. XIII, London, May 1931; R. H. Wilenski, *The Meaning of Modern Sculpture*, London—New York 1932; A Stokes, 'Mr Henry Moore's Sculpture', in *The Spectator*, vol. CLI, London, November 1933; A. L. Haksell, *Black and White*, London 1933; G. Grigson, 'Henry Moore and Ben Nicholson', in *The Bookman*, London, November 1933; N. Furst, 'Sculpture and drawings by Henry Moore at the Leicester Galleries', in *Apollo*, vol. XVIII, London, December 1933; H. Read, *Henry Moore, Sculptor*, London 1934; J. M. Richards, 'Henry Moore, Sculptor', in *Architectural Review*, vol. 76, London, September 1934; G. Grigson, 'Henry Moore and Ourselves', in *Axis*, n. 3, London, July 1935; G. Grigson, 'Hyldest til Henry Moore', in *Konkretion*, n. 3, Copenhagen, November 1935; S. Woods, 'Henry Moore', in *Axis*, n. 7, London, Autumn 1936; G. Bell, 'Henry Moore', in *New Statesman and Nation*, vol. XII, London, November 1936; J. Piper, 'England's early sculptors', in *The Painter's Object*, London 1937; J. Piper, 'Lost, a valuable object', in *The Painter's Object*, London 1937; R. S. Lambert, *Art in England*, Harmondsworth 1938; W. Rothenstein, Since Fifty: *Men and Memoires, 1922–1938*, London 1939; E. L. T. Mesens, 'Letter to the Editor of New Statesman and Nation', in *London Bulletin*, nn. 18–20, London, June 1940; R. Mortimer, 'The Leicester Galleries', in *New Statesman and Nation*, vol. XIX, London, February 1940; G. Onslow-Ford, 'The Wooden Giantess of Henry Moore', in *London Bulletin*, nn. 18–20, London, June 1940; D. Sutton, 'Henry Moore and the English Tradition', in *Kingdom Come*, vol. II, n. 2, Oxford 1940; P. Hendy, 'Henry Moore', in *Horizon*, vol. IV, n. 21, London, September 1941; K. Clark, 'Henry Moore, a Note on his Drawings', in *Henry Moore, 40 Watercolours and Drawings*, catalogue of the exhibition at the Buchholz Gallery, New York 1943; G. Grigson, *Henry Moore*, Harmondsworth 1943; K. Clark, 'A Madonna by Henry Moore', in *Magazine of Art*, vol. XXXVII, Washington D.C., November 1944; D. Cooper, review of *Sculpture and Drawings*, in *Horizon*, vol. X, n. 60, London, December 1944; E. Newton, 'Henry Moore and Leonardo', in *The Listener*, vol. XXXII, n. 820, London, September 1944; H. Read, *Henry Moore,*

Sculpture and Drawings, London–New York 1944; P. Hendy, 'Henry Moore', in *Britain Today*, n. 106, London, February 1945; Rev. J. W. A. Hussey, *Statue of Madonna and Child in S. Matthew's Church*, Northampton 1945; R. Motherwell, 'Henry Moore', in *New Republic*, vol. CXIII, n. 17, New York, October 1945; N. Pevsner, 'Thoughts on Henry Moore', in *The Burlington Magazine*, vol. LXXXVI, London, February 1945; W. R. Valentiner, *Origins of Modern Sculpture*, New York 1946; E. Sackville-West, 'A Sculptor's Workshop: Notes on a new figure by Henry Moore', in *The Arts*, n. 1, London 1946; H. Read, *Henry Moore, Sculpture and Drawings*, II edition, London 1946; W. Lewis, Moore and Hepworth, in *The Listener*, vol. XXXVI, n. 927, London, October 1946; J. J. Sweeney, *Henry Moore*, catalogue of the first retrospective exhibition of Moore in USA, Museum of Modern Art, New York 1946; L. P. J. Braat, 'Tastend en Testend', in *Kronick van Kunst en Kultur*, vol. VIII, Amsterdam 1947; C. Greenberg, 'Henry Moore', in *The Nation*, vol. CLXIV, New York, February 1947; L. Kochnitzki, 'Henry Moore', in *View*, vol. VII, n. 3, New York, March 1947; R. Ironside, *Painting since 1939*, London–New York 1947; D. Loshak, 'Henry Moore and Aspects of Modern Sculpture', in *Critique*, vol. 1, n. 3, New York, January–February 1947; J. D. Morse, 'Moore comes to America', in *Magazine of Art*, vol. XI, Washington D.C., March 1947; C. Turnbull, 'The Art of Henry Moore', in *Meanjin*, 1947; F. Wight, 'Henry Moore: The Reclining Figure', in *Journal of Aesthetics and Art Criticism*, vol. VI, n. 2, Baltimore, December 1947; G. C. Argan, *Henry Moore*, Turin 1948; A. Alexandre, 'Der englische Bildhauer, Henry Moore', in *Der Standpunkt*, Stuttgart, January–February 1948. R. Arnsheim, 'The Holes of Henry Moore', in *Journal of Aesthetics and Art Criticism*, vol. VII, n. 1., Baltimore, September 1948; G. Marchiori, 'Henry Moore', in *Il Mattino del popolo*, Venice, 15 August 1948; G. Grigson, 'Authentic and False in the New Romanticism', in *Horizon*, vol. XVII, n. 99, London, March 1948; J. Russell, *From Sickert to 1948*, London 1948; A. D. B. Sylvester, 'The Evolution of Henry Moore's Sculpture', in *The Burlington Magazine*, vol. XC, London, June–July 1948; R. Vrinat, 'L'Evolution de la figure couchée dans l'oeuvre de Henry Moore', in *L'Age Nouveau*, Paris, November 1949. H. Read, *Henry Moore, Sculpture and Drawings*, 3rd edition revised, London 1949; P. Hendy, 'Henry Moore: his new exhibition', in *Britain Today*, n. 158, London, June 1949; L. Degand, 'Henry Moore', in *Art d'Aujourd'hui*, n. 4, Paris, November 1949; G. Limbour, 'Deux Sculpteurs: Henry Moore, Adam', in *Les Temps Modernes*, Paris, January 1950; U. Conrads, 'Begegnung mit Henry Moore', in *Das Kunstwerk*, vol. 4, nn. 8–9, Baden-Baden 1950; A. Elter, 'Englands Grosser Bildhauer: Henry Moore', in *Europaische Illustrierte*, n. 51, March 1950; B. Storey, 'Una retrospettiva di Moore', in *Emporium*, vol. 3, Bergamo 1950; C. Falkenstein, 'Work of Henry Moore', in *Art and Architecture*, vol. 67, Los Angeles, October 1950; J. Hodin, 'Henry Moore', in *Kronick van Kunst en Kultur*, vol. 11, n. 1, Amsterdam, January 1950; T. Brunius, 'Henry Moore', in *Paletten*, vol. 11, n. 3, Göteborg 1950; K. Clark, 'Henry Moore's Metal Sculpture', in *Magazine of Art*, vol. 44, New York, May 1951; F. Finne, 'Henry Moore', in *Kunsten Idag*, vols. 18–19, nn. 2–3, Oslo 1951; D. Mathews, 'Sculptures and Drawings by Henry Moore', in *Art News and Review*, vol. 3, n. 7, London, May 1951; H. McBride, 'Four Trans-oceanic Reputations', in *Art News*, New York, January 1951; W. Stabell, 'Henry Moore', in *The Norseman*, vol. IX, n. 3, May–June 1951; G. Svensson, 'Henry Moore', in *Konstrevy*, Stockholm 1951; A. Widlund, 'Henry Moore', in *Damernas Varld*, n. 42, 1951; W. J. Strachan, 'Henry Moore's Prométhée, experiments for a book', in *Image*, summer 1952; E. I. Musgrave, 'The Reclining Figure', in *Leeds Art Calendar*, vol. 5, n. 17, 1952; R. Melville, *Henry Moore*, introduction to the retrospective exhibition of drawings, I. C. A., London 1952; R. M. Alford, 'A Visit to Henry Moore', in *Museum Notes*, vol. 9, n. 2, Providence, Rhode Island, January 1952; O. Beyer, 'Die Madonnen Henry Moores', in *Almanach auf das Jahr des Herrn*, Hamburg, 1952; L. Alloway, 'Sutherland and Moore', in *Art News and Review*, vol. 5, n. 9, London 1953; U. Gertz, *Plastik der Gegenwart*, Berlin 1953; A. Hentzen, *Henry Moore*, introduction to the exhibition, Hanover, July–August 1953; A. Haukeland, 'Omkring tre Billedhuggeres Utstillinger i Oslo', in *Bonytt*, Oslo 1953; 'Henry Moore 1950, 51, 52', in *Domus*, Milan, February 1953; C. Holden, 'Henry Moore', in *Paletten*, n. 3, Göteborg 1953; V. Martinelli, 'Scultura moderna all'aperto', in *Commentari*, vol. 4, n. 4, Rome 1953; H. Read, 'The Dynamics of Art', in *Eranos-Jahrbuch*, XXI, Zurich 1953; A. C. Ritchie, *Sculpture of the Twentieth Century*, New York 1953; R. Schapire, 'Henry Moore', in *Die Weltkunst*, XXIII, Monaco, September 1953; P. De Vree, 'Henry Moore', in *Bouwen en Wonen*, n. 4, March 1954; E. Trier, *Moderne Plastik: Von Auguste Rodin bis Marino Marini*, Berlin 1954; E. Newton, *In My View*, London–New York–Toronto 1954; F. Man, *Eight European Artists*, London 1954; K. Gerstenberg, 'Besuch bei Henry Moore', in *Die Kunst und das Schöne Heim*, vol. 52, n. 6, Monaco, March 1954; H. Read Henry Moore: *Sculpture and Drawings since 1948*, 1955; second, revised edition, *Sculpture and Drawings 1949–1955*, 1965; M. Negri, 'Henry Moore', in *Domus*, Milan, September 1955; D. Sylvester, 'Henry Moore's Recent Sculptures', in *The Listener*, London, November 1955; J. Berger, 'Abandon Hope', in *The New Statesman*, London, November 1955; J. Russell, 'Mr Moore', in *The Sunday Times*, London, November 1955; S. Walter, *Henry Moore*, Cologne 1955; J. P. Hodin, *Henry Moore*, London 1956; H. T. Flemming, *Henry Moore: Katakomben*, Monaco 1956; Milan 1959; P. Heron and B. Taylor, 'Henry Moore', in *Encounter*, London, February 1956; P. Heron *The Changing Forms of Art*, London 1956; J. P. Hodin, *The Dilemma of Being Modern*, London 1956; H. Read, *The Art of Sculpture*, London 1956; P. A. Reidi, *Henry Moore König und Königin*, Stuttgart 1957; H. Read and D. Sylvester, *Henry Moore, Volume 1: Sculpture and Drawings 1921–48*, 4th edition; P. Volbodt, 'Moore', in *XX Siècle*, Paris, June 1957; J. P. Hodin, 'Henry Moore–Work in Progress', *Das Kunstwerk*, Krefeld, August 1957; T. Hopkinson, 'How a Sculptor Works', in *Books and Art*, London, November 1957; J. P. Hodin, 'Neuere Werke Henry Moores', in *Werk*, Winterthur, August 1958; D. Thompson, 'Insight into Henry Moore's Creative

Thought', in *The Times*, London, 20 October 1958; W. J. Strachan, 'Henry Moore's Unesco Statue', in *The Studio*, London, December 1958; R. Melville, 'New Pieces on View at the Hanover', in *Architectural Review*, London, October 1958; W. Hofmann, Henry Moore, *Schriften und Sculpturen*, Frankfurt 1959; W. Grohmann, *Henry Moore*, Berlin 1959, London 1960; E. Neumann, *The Archetypal World of Henry Moore*, London 1959; R. Penrose, 'Henry Moore: Reclining Figure', in *Quadrum*, n. 6, Brussels 1959; D. Sutton, 'Henry Moore: A Sculptor's Vision', in *New York Times*, 23 March 1959; R. Melville, 'Henry Moore: the recent sketchbooks', in *Graphis*, Zurich, September–October 1959; A. Hentzen, private catalogue at Hamburg, 1960; B. Robertson, private catalogue at the Whitechapel Art Gallery, London 1960; G. Grigson, 'Hunting the Norm', in *The Observer*, London, 24 July 1960; A. Caro, 'The Master Sculptor', in *The Observer*, London, 27 November 1960; R. Campbell, 'A Sculptor's Themes', in *The New Statesman*, London, 20 August 1960; N. Wallis, 'Elemental Moore', in *The Observer*, London, November 1960; J. Russell, 'Ten Years of Expansion', in *The Sunday Times*, London, November 1960; D. Thompson, 'Mr Henry Moore's Exhilarating Exhibition', in *The Times*, London, November 1960; K. Sutton, 'Henry Moore at Whitechapel', in *The Listener*, London, December 1960; D. Sylvester, 'Ten Years of Henry Moore', in *The New Statesman*, London, December 1960; J. Freeman, 'Henry Moore on Sculpture', part of the interview 'Face to Face' on the BBC, in *The Listener*, London, March 1960; D. Hall, 'Henry Moore', interview, in *Horizon*, New York, November 1960; D. Sindelar, *Henry Moore*, Prague 1961; P. Bucarelli, *Henry Moore*, introduction to British Council Exhibition, Paris 1961; J. Russell, *Henry Moore; Wood and Stone Carvings*, Marlborough Exhibition, London 1961; A Bowness, 'The Sculpture of Henry Moore', in *Arts*, New York, February 1961; B. Robertson, 'Notes on Henry Moore', in *The Museum Journal*, London, February 1961; H. T. Flemming, 'Henry Moore', in *Die Kunst and das Schöne Heim*, Monaco, February 1961; L. Trucchi, 'Henry Moore', in *Corriere Mercantile*, Rome, February 1961; M. C. Rueppel, 'Two early works by Henry Moore'; A. Ritchie, 'Dedication of the Moore Figure at Lambert Airport Plaza', in *St Louis Museum Bulletin*, XLV, 1961; E. Fezzi, 'I grandi corpi di Henry Moore', in *La Provincia*, April 1961; D. Thompson, 'Henry Moore–An Artist in the Great European Tradition', in *The Times*, London, 23 June 1961; N. Wallis, 'Moore in Stone and Wood', in *The Observer*, London, 25 June 1961; J. Russell, 'Henry Moore: A Man Alone', in *The Sunday Times*, London, 25 June 1961; D. Sylvester, 'Moore's Carvings', in *The New Statesman*, London, 7 July 1961; P. Rouve, 'The Young Moore', in *The Arts Review*, London, 15 July 1961; C. Lake, 'Henry Moore's World', in *Atlantic Monthly*, Boston, January 1962; G. Marchiori, 'Lo scultore Henry Moore', in *Marmo*, n. 1, Milan 1962; H. Read, *A Letter to a Young Painter*, London 1962; S. Tillim, 'Exhibition at Knoedler', in *Arts*, New York, May 1962; D. Thompson, 'Moore's New Line', in *The Times*, London, 12 July 1962; J. Russell, 'The Old and New Moore', in *The Sunday Times*, London, 22 July 1962; N. Gosling, 'Inside the Cavern', in *The Observer*, London, 29 July 1962; J. P. Hodin, *Moore*, Buenos Aires 1963; D. Thompson, 'New York by Henry Moore and Francis Bacon', in *The Times*, London, 12 July 1963; N. Gosling, 'Vision and Nightmare', in *The Observer*, London, 14 July 1963; T. Mullaly, 'Henry Moore at his best', in *The Daily Telegraph*, London, 15 July 1963; A. Forge, 'What Art can Encompass', in *The New Statesman*, London, 26 July 1963; G. Baro, 'Bond Street and Battersea', in *Arts*, New York, October 1963; W. Forma, *Five British Sculptors (Work and Talk)*, New York, 1964; H. Read, *Henry Moore*, catalogue to the exhibition at King's Lynn Festival, 1964; H. Read, *Henry Moore*, catalogue to the British Council Exhibition in Mexico, Brazil, Argentina, 1964; M. Levy, 'Henry Moore. Sculptor Against the Sky', in *Studio International*, London, May 1964; E. Mullins, 'Reflections on Henry Moore', in *The Sunday Telegraph*, London, 1 March 1964; H. Read, 'Henry Moore and the Renaissance of Sculpture in England' (lecture), reprinted in Caracas catalogue, 1964; R. Melville, 'Moore at Lynn', in *Architectural Review*, London, November 1964; G. Giubbini, 'L'influsso di Picasso sull'arte di Moore', in *Commentari*, Rome, January–June 1964; H. Read, *Henry Moore–Sculpture and Drawings. Sculpture 1955–64*, Vol. 3, London 1965; L. Lambertini, 'Incontro al mare con la scultura', in *L'Avvenire d'Italia*, 11 August 1964; H. Read, 'A Nest of Gentle Artists', in *Art in Britain 1930–40*, catalogue of the exhibition at Marlborough Gallery, London 1965; E. Garfield, 'Lettera de Londra', in *D'Ars Agency*, n. 3, 1965; V. Sherman, *Anni Sessanta–Scultura britannica a Londra*, in *D'Ars Agency*, no. 3, 1965; H. Read, *Henry Moore*, London 1965; G. Baro, 'Britain's New Sculpture', in *Art International*, n. 6, 1965; A. Bowness, *Modern Sculpture*, London 1965; A. M. Hammacher, *Modern English Sculpture*, London 1967; U. Kultermann, *Neue Dimension der Plastik*, New York–London–Tubingen 1967; G. Marchiori, 'La scultura in Europa fra le due guerre', in *L'Arte Moderna*, n. 88, Vol. X, Milan 1967; S. Zamboni, *Henry Moore*, Milan 1967; 'Henry Moore', in *Photographs by John Hedgecoe* (with comments by the sculptor), London 1968; G. Marchiori, 'Il dopoguerra in Europa', in *L'Arte Moderna*, n. 104, vol. XII; R. Barilli, *La scultura del Novecento*, Milan 1968; D. Sylvester, *Henry Moore* (catalogue of exhibition at the Tate Gallery), London 1968; K. Roberts, 'Current and Forthcoming Exhibitions', in *The Burlington Magazine*, London, May 1968; G. Ponti, 'Da Londra alla casa di Moore', in *Domus*, June 1969; H. L. Jaffé, *L'Arte del XX secolo*, Florence 1970; M. Valsecchi, 'Henry Moore', in *Tempo*, n. 38, September 1970; G. C. Argan, *Arte Moderna 1770–1970*, Florence 1970.

FILMS AND TELEVISION PROGRAMMES

Sculpture in the open air, a recorded talk by Henry Moore, edited by Robert Mellville, and made by the British Council, illustrated with a film strip, 1955; *Is Art Necessary? Encounters in the Dark*, ATV programme, directed by Leonard Brett: Henry Moore with Kenneth Clark in the British Museum, 17 March 1958;

Sculptor's Landscape, BBC television film, made by John Read, photographs by Walter Lassally, June 1958; *Henry Moore*, A Monitor programme on BBC television, with Huw Wheldon, directed by Nancy Thomas, 20 November 1960; *Henry Moore, London 1940–42*, film by Anthony Roland, May 1963; *Henry Moore*, film-interview, Italian TV, text by De Marchis, 11 June 1968.

BOOK AND MAGAZINE ILLUSTRATIONS

Contemporary Poetry and Prose, n. 9 (cover design), London 1937; Henry Moore, *Shelter Sketch Book*, New York, 1945; Edward Sackville-West, *The Rescue, a melodrama for broadcasting based on Homer's Odyssey*, with illustrations by Henry Moore, London 1945; Shimanski, Stefan and Treece, *A Map of Hearts* (cover design), London 1944; *Ganymed Prints of Sculptor's Drawings* (with colour reproductions by Henry Moore), London 1950; Wolfgang Goethe, *Prométhée*, translation by André Gide, lithographs by Henry Moore, Paris 1950; Jacquetta Hawkes, *A Land*, with Drawings by Henry Moore, London 1951; Murray Hickey Ley, *A is All* (frontispiece and inside of cover), San Francisco 1953; Henry Moore, *Original Lithographs*, 'XX Siècle' n. 1, Paris 1951; *Meditations on the Effigy*, with lithographs and engravings by Henry Moore, London 1968.